Living Treasures: Masters of Australian Craft

object **CH** CRAFTSMAN HOUSE

Klaus Moje:Glass

Megan Bottari

First published in Australia in 2006
Published to coincide with the exhibition, *Klaus Moje: Glass*,
shown from 11 November 2006 – 7 January 2007 at
Object Gallery, Sydney before touring throughout Australia.

Craftsman House
An imprint of Thames & Hudson Australia Pty Ltd,
Portside Business Park, Fishermans Bend, Victoria, 3207
www.thamesandhudson.com

Object: Australian Centre for Craft and Design
415 Bourke Street, Surry Hills, NSW, 2010
www.object.com.au

Bottari, Megan, 1955-
 Klaus Moje: Living Treasures: Masters of Australian Craft.

 1st ed.
 Bibliography.
 ISBN 9780975768471.

 ISBN 0 9757684 7 6.

 1. Moje, Klaus, 1936 2. Glass artists - Australia - Biography.
 3. Glass art - Australia. I. Title.
 (Series : Living Treasues: Masters of Australian Craft).

 748.092

Design: Lynda Warner
Photography: Klaus Moje
Archival Photography: Unknown unless stated
Copy Editing: Emily Howes and Annabel Moir
Production: Imago
Printed in China

All measurements are height before width by depth.

Object: Australian Centre for Craft and Design is a non-profit organisation
supported by the Visual Arts and Craft Strategy, an initiative of the Australian,
State and Territory Governments. Object is assisted by the New South Wales
Government – Arts NSW, and the Australian Government through the Australia
Council, its arts funding and advisory body.

This project has been supported by Bullseye Glass Co., the ACT Government
through Arts ACT, the Australian National University School of Art, the Thomas
Foundation, Museums & Galleries New South Wales, Craft Australia, Visions of
Australia and by Object's National Exhibitions Strategy funded by the Australia
Council.

Contents

Foreword

Now in its second year, 'Living Treasures: Masters of Australian Craft' is a major commitment by Object to celebrate the achievements of the most influential and iconic figures within the Australian crafts movement. Each year we plan to present a solo exhibition of new work by artists whose mastery of skill and contribution to the sector is worthy of broad national recognition.

Object is delighted to be working closely with a number of other key organisations to enhance and promote the 'Living Treasures' series. Each exhibition will be toured to regional and metropolitan venues across Australia by Museums & Galleries New South Wales. Craft Australia will be supporting the exhibitions through various events and on-line activities and we will continue to work with the University of Wollongong, testing new ideas in exhibition interpretation and audience evaluation through an Australian Research Council Linkage Project Grant.

'Living Treasures' is an integral part of Object's National Exhibitions Strategy, a program supported by the Australia Council aimed at developing collaborative exhibitions of contemporary craft and design that are national in scope and relevance. The development of the 'Living Treasures' concept involved substantial input from the national network, Australian Craft and Design Organisations (ACDO).

The 'Living Treasures' project began with a consultative process that saw more than 60 highly respected artists nominated through the ACDO network in early 2004. A jury of curators from around the country then selected ceramicist, Les Blakebrough (2005), glass artist, Klaus Moje (2006) and jeweller, Marian Hosking (2007) as the first three 'Living Treasures'. I would like to thank the jurors; Kirsten Fitzpatrick, Janice Lally, Kevin Murray, Andrew Nicholls, Catrina Vignando,

and Object's Associate Director, Brian Parkes, who chaired the jury and has since curated both the Blakebrough and Moje exhibitions.

Publishing a significant monograph to accompany each exhibition was a critical objective for the 'Living Treasures' series and Object is proud to be working once again with Thames & Hudson Australia through their Craftsman House imprint, and with acclaimed graphic designer, Lynda Warner. This important publication has also been assisted by the Thomas Foundation and by Bullseye Glass, and I would like to thank David Thomas, Lani McGregor and Daniel Schwoerer in particular for their generous support.

Klaus Moje is recognised in at least three continents as a towering figure in the contemporary crafts movement and is an essential inclusion in this series. His almost unparalleled contribution to the field as an artist, educator, mentor and advocate is aptly reflected throughout the pages of this book. Megan Bottari's thorough and wonderfully written text – for which she deserves special thanks – reveals the story of Moje's extraordinary life so far and the passions that have driven him for more than 50 years.

Steven Pozel
Director
Object: Australian Centre for Craft and Design

Acknowledgements

In what has been a rather tumultuous and fast-and-furious ride there are many people to thank for their extremely patient accommodation. First and foremost I would like to thank Object: Australian Centre for Craft and Design for giving me the opportunity to be a part of this wonderful project; and particularly Brian Parkes, who has been a driving force for the 'Living Treasures' project and (importantly from my point of view!) this accompanying publication. With some third of the primary material being written in German, patently a little help didn't go astray in the translation department(!), and my gratitude necessarily goes to Irene Hansen, Sammy Jo Bottari, Ceci Wilkinson, Gilbert Riedelbauch and Antonia Lehn.

Sincere thanks also to the several 'boutique contributors' who, on very short notice indeed, sent the many pearls that seed the text: Walther and Karin Zander, Dr Rüdiger Joppien, Lino Tagliapietro, Doug Heller, Udo Sellbach, Dan Klein, Lani McGregor, Susan Steinhauser and Daniel Greenberg, Professor David Williams, Dr Helmut Ricke, Julie Ewington, Kirstie Rea, Geoffrey Edwards, Henry Halem, Scott Chaseling, Richard Whiteley, Grace Cochrane, David Revere McFadden, and Professor Dr Heinz Spielmann. At the ANU School of Art, heartfelt thanks must be extended to Nigel Lendon and David Williams for their manifold and kind facilitations, and bucket-loads of appreciation goes to the crew support on the ground; Jacqueline Gropp, Itzell Tazzyman, Ginger Bottari and Sally Howes. But the biggest thanks of all must be reserved for the long suffering spouses, Brigitte Enders and Sammy Bottari, who, through their enduring tolerance, made this most intrusive of processes at all possible.

And to Klaus: *inter nos*... 'Ja und?'

Megan Bottari

Introduction

The inclusion of glass artist Klaus Moje in the inaugural selection of artists for Object Gallery's 'Living Treasures: Masters of Australian Craft' project lends deserved and added distinction to an already illustrious and fêted career. Hailed internationally as the founder of modern kiln-formed glass, he is not only one of the most influential and iconic figures within the Australian studio-glass movement, his significance clearly reaches far beyond. Moje's reputation carries the authority of a 50-year practice that spans three continents and stands testimony to a mastery that resonates with iron-bark integrity.

But Moje's career is far greater than the sum of his vast catalogue of works. A life story of almost filmic proportion reveals a pioneering protagonist, one of a band of studio-glass brothers carving an audacious modern chapter into the chronicles of glass history. This seemingly extravagant statement is made entirely without hyperbole. That the studio-glass movement constituted an artistic renaissance, at a time when glass was predominantly an industry of manufacture, is simply irrefutable. And Moje was a standard-bearer of the revolution, riding the wave of a career that itself appears beautifully weighted, almost crafted, into the classic structure of a three-act play.

In latter years, courtesy of his age, era and ethnicity, Moje has borne the stamp of the pedagogue, but is in reality a charming and benign dictator, and generous mentor to all who share his vocational zeal. Above all, he has remained a staunch advocate for his craft, tirelessly bringing his increasing influence to bear on the advancement of both professional practice and colleagues alike. In the 25 years he has resided in Australia he has demonstrated an unwavering commitment to both the development of Australian studio glass and to the promotion of its profile abroad. In truth, however, he has never been an isolate or patriot in any provincial sense – in both practice and philosophy he remains a glass citizen of the world.

This monograph has no intention of delivering a pat, prosaic chronology of his career. It will endeavor instead to paint the picture of the man: apostle, artist, innovator, friend. The career will supply the bones.

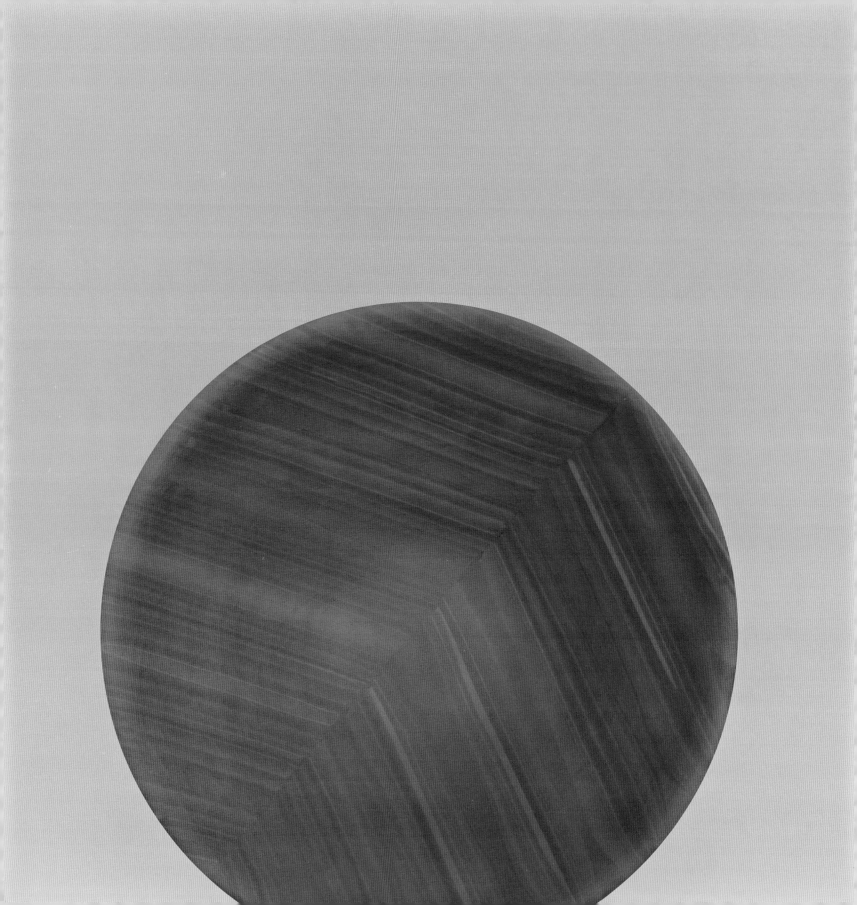

Act One: The Early Years

Klaus Moje was born into quite unpretentious circumstances in Hamburg, Germany, in 1936. His parents, Hugo and Dora Moje, operated a modest glass cutting and grinding workshop, Hugo Moje Glasschleiferei, which his father had established in the late 1920s to provide bevelling and engraving services to the glazier trade. There was nothing grandiose in the production, just commonplace commercial work: the standard decorative detailing for mirrors and glass panels – the ubiquitous swan, a floral motif, the barest of deco patterning. At its height the workshop employed up to eight tradesmen, but the outbreak of war saw Hugo and his able-bodied workers drafted into the German Army, leaving Dora with a skeleton crew to run an inevitably dwindling business.

In accordance with standard wartime practice the boy was sent into foster care for safety, billeted at a farm 50km east of Dresden. There, despite the initial anxiety of living with strangers, he was to spend a comparatively agreeable time (a subsisting diet, if meager, and only the occasional strafing from Russian fighter planes on the 3km walk to school).

Some two years later, in the autumn of 1943, when the Allied bombing of Hamburg razed much of that city to the ground, the glassworks miraculously survived unscathed. Not so the Moje family home. With little left to salvage, Dora boarded up the workshop, packed her regulation suitcase,[1] and took refuge with her son in the country. There they maintained survival mode until the imminence of war's end was plainly evidenced by the passing parade of German infantry withdrawing towards Berlin. The radio announcement of the official ceasefire came barely abreast of the Russian frontline – a thrill of crack troops and Mongolian cavalry – which, to the great relief of all, passed quickly through.

Then, at last, amidst the constant traffic of the rear echelons and ordinance, mother and son packed up their hand-cart and joined the slow march home.

The Allies carved post-war Germany up into zones – British, French, American and Russian – with Hamburg apportioned to the British. On announcement of the armistice Hugo became a British POW, but was released the next day and his repatriation to the rubble of their former existence was prompt and orderly. By the time the family joined him, he had managed to prepare an adequate nest for them all in the workshop. There followed a period of extreme turmoil and hardship, ameliorated only by the chance preservation of the glassworks, which – courtesy of the former downturn in business – had remained relatively well-stocked. In an environment of wholesale devastation where supplies were scarce, rations bare and the population forced to eke out an existence as best they might, this trove of materials delivered Hugo a valuable bartering tool. He was able to start up the glassworks almost immediately and trade his commodities for food and goods to sustain his family and share among his workers. In the winter months, Klaus, at nine years old, joined neighbourhood children in clandestine raids across the frozen river to the railway sidings to pilfer coal from shunted wagons.

The reformation of currency in 1948[2] signaled a return to quasi-normality, by which time young Klaus was earning his pocket money cleaning and grinding glass for his father, and cycling far and wide to deliver bundles of mirror tucked precariously under his arm. Until the following year when poliomyelitis struck – hospitalising him for an anxious nine months before his escape to the protractions of rehabilitation. The physiotherapy sessions in time progressed to a fitness regime with a strong emphasis on sport, swimming most

14

1 Only a suitcase of a certain size was permitted in bunkers.
2 The 'Waerungsreform', when the reichmark changed to deutschmark and everybody was issued a base capital of 100 deutschmarks.

The work force at 'Hugo Moje Glasschleiferei'.
Klaus third from left.

particularly. By his 15th birthday he was fully recovered and back in the swing. This was the year he commenced his glass grinding apprenticeship with his father, won the under-16 long distance swimming championship and joined, through friendships made at swimming training, the local Christian youth group. Involvement in this group would later prove very significant, but for now it simply provided the fundamentals to hone his leadership skills and underpin his moral principles. Pleasure was not excluded from the mix. Here he also began a passionate involvement in music, as a singer/songwriter/guitarist of the German folk persuasion, and he was plainly no slouch on the dance floor – by the following year he'd even picked up the crown at the local 'King of the Waltz' competition. The one calamity was his mother's health. Dora had suffered a stroke that same year, with medical complications that eventually resulted in the amputation of her legs. Her nursing requirements would prove more than the household could bear and before long she'd be admitted to a hospice.

But it was the apprenticeship that most defined his existence at this time, though let there be no romantic suggestions of an inherent artistic imperative (not at this juncture, at any rate). Signing up for the apprenticeship was part filial duty, part dearth of other prospects. It was merely the pathway to a job, as opposed to a career. There was certainly no particular consciousness or nurturing of the arts within Moje's home environment. His own aesthetic awareness grew entirely independently via friends and natural curiosity, and he had collected art books from a relatively early age, though never with any prescient sense of purpose. What he did have, however, was a steady will and a driving compulsion to do things well. In fact he took such elaborate care in his work and applied himself so diligently to the apprenticeship that

by its conclusion he had gained not only his Journeyman's Certificate but also the distinction of being named German Apprentice of the Year. One of his final apprenticeship pieces, a hand mirror with baroque faceting, remains in his possession to this day.

The award bore useful fruit in the form of a stipend for further education. Moje commenced his studies at the Rheinbach Glass School near Bonn, but soon found it to be unsatisfactorily restrictive. The school's rigid curriculum limited students to the specific stream of their Journeyman's Certificates, giving him only the option of cutting and engraving, which amounted to little more than an extension of the apprenticeship. Out of curiosity, he and fellow student Heribert Klösgen drove across to the Hadamar Glass School near Frankfurt and were instantly struck by the broader range of opportunity there. Where Rheinbach adhered so strictly to techniques applicable to industry, Hadamar offered tantalising choice – lead-lighting, painting, engraving, grinding, etching, sandblasting, mosaic (terrazzo) – with an emphasis on the decorative. Run more along the lines of a preparatory school for further art studies, Hadamar's most potent lure was its licence for exploration.

They transferred immediately, and Moje recalls the time fondly as his 'first contact with the beautiful side of glass'.[3] The faculty comprised an intriguing mix of progressive artists and master craftsmen, and inspiration sprang from a medley of influences. Of the craftsmen, some had returned post-war from Bohemia where they had been trained in traditional techniques that hadn't been used in decades. They 'knew the craft'; they were true artisans. 'This was a very happy environment for me, and I, like a sponge, grabbed whatever I could from this great reservoir of knowledge'.[4] The Hadamar

3 Klaus Moje, in interview with Megan Bottari.
4 Klaus Moje, from the 'Spotlights' speech given at the Glass Art Society conference, Adelaide, 2005.

experience was to change the course of his career, and not the least because it was also here that he met fellow under-graduate student and wife-to-be Isgard Wohlgemuth.

In 1959, when Moje graduated with a Master's Certificate in glass cutting and etching (Wohlgemuth had finished a year earlier with a diploma in glass painting), any nascent ambition to establish a studio had to be put on hold. Reality bit, and bare necessity obliged them both to seek employment in industry. Wohlgemuth found work as a designer in a lighting company, while Moje took first a job in the Ruhr Area, Germany's industrial region, at a place that manufactured screen-prints for glass packaging, followed later by another in Limburg an der Lahn as operations manager in a crystal chandelier factory. They were finally released from this factotum drudgery by their first stained-glass commission, which came circuitously through old connections. Moje's Christian youth group had approached his father Hugo for advice regarding the fabrication of some chapel windows, and Hugo, being the first to acknowledge that the project was beyond his capabilities, immediately referred them on to his son. Klaus and Isgard accepted the job without hesitation, particularly as Limburg was located conveniently close to Hadamar, and they would be able to access the school facilities to accommodate a good deal of the process.

The commission, as it happened, turned out to be one of considerable cachet. The Mojes found themselves working for the former Bauhaus master painter Lothar Schreyer, on a design that consisted of a series of 13 meditation windows based on the theme of Father, Son and Holy Ghost.

It represented a mammoth undertaking and would prove to be a seminal experience; their induction to the thrill of collaborative resolution. The job called for three base colours (red, blue and yellow) to build up gradually across the 13 windows towards climactic saturation in the central three. These days, of course, with modern fusing techniques the task would be relatively simple, but back then it required meticulous multi-layering of etched and painted plates to graduate the rich kaleidoscopic composition. Schreyer's design was strictly Bauhaus – a construct of calculated line and carefully weighted colour – and the 600 x 400mm panels, with up to seven layers of glass embedded in epoxy, made for heavy and painstaking work. The windows took three months to complete and conditions were hazardous, with high use of acids and nary a hint of occupational health and safety. Any discomfort, however, was more than offset by the exhilaration of independent, creative employment. In fact the experience had been encouraging enough to prompt them to set up business on their own. They'd just begun to cast about for suitable studio space when Hugo offered them the Glasschleiferei. In Dora's absence (it was she who had been the effective manager of the place) it had suffered such a decline in business that the workshop by now was as good as defunct. In what would become a recurrent refrain in the Moje career, it was great timing.

On the heels of the Schreyer job the Mojes secured a commission for a 30 square-metre window installation for the Christus Kirche in Wandsbek. This and subsequent commissions were supplemented by restoration work and the odd trade job, including a bread-and-butter line of beveled mirrors and commonplace glass shelving, which continued to dribble in from the old glazier connections. But it wasn't the nature of the work that was consequential so much as the attendant associations. The Mojes found themselves mixing with an ever-widening circle of acquaintances, many of whom

The window commission for the Christus Kirche in Wandsbek, Hamburg.

1964 Moje recording music in the Schwann Studios, Düsseldorf.

taught at the Hochschule für Bildende Künste in Hamburg, had studied at the Bauhaus or were fellow artist-craftsmen who shared an evolving and progressive attitude towards all matter of topical material concerns.

In this fomenting and ideological climate there was even radical creative change afoot on the domestic front: baby Jonas arrived in 1962, followed by Mascha in 1964. Moje's early passion for music had also continued unabated - if anything it was developing into a far more serious pursuit. Since 1960 he'd been composing music to the lyrics of activist and poet Hildegard Wohlgemuth, his mother-in-law and member of a left-wing colony of writers and poets located in the Ruhr Area. This venture would lead to a number of recordings and regular singing engagements in a folk club in Hamburg, an arrangement that continued throughout the decade and, indeed, well into the 1970s.

After the Schreyer windows the most memorable commission during this early period involved a two-month trip to Jordan to restore and install a set of Lutheran windows, circa 1880, which were being relocated from Jerusalem to the church attached to a German school in Amman. (The faces of the figures had been shot out of every panel in an act of rancorous wartime vandalism.) While work left little time to spare for sightseeing, they did manage to arrange a diving trip in the Gulf of Aqaba. It would be Moje's first opportunity to dive in tropical waters and, after the interminable drive across a desert landscape bleached achromatic by the relentless sun, the eventual plunge into a coral sea teeming with exotic fish delivered such an unexpected explosion of colour and movement that it left a profound and indelible impression on him. It was an experience that led to a lifelong passion for diving, but more importantly it represented a

critical moment of aesthetic shift: the triggering of a sharpened, innate affinity with colour.

In fact, this Jordanian sojourn, though brief, delivered a swag of revelations. Fascinated as Moje was by the traditional vessels and shards discovered in souks and 'dig' sites, it was the architectural applications of glass that caught his attention, most particularly the simple patterning of coloured glass panels set blunt into huge plaster planes. Having come from a European window tradition that was so figuratively familiar and conventionally proscribed, the delicacy and sensitivity of the Arabic design solutions - limited by Islamic decree to decorative device only - struck a deep empathetic chord. He found himself utterly captivated by the strength of the ornamental constraint. Categorical declarations regarding sources of influence on any artist's practice is often a futile exercise, there being too many contributing environmental and emotional nuances laminating the psyche. However, in this instance, it wouldn't be unreasonable to suggest that 'colour' and 'constraint' may have hitched a ride back to Hamburg on the wings of Moje's subconscious.

They returned to the studio with a determination to start developing work of their own making. This desire was made all the keener as they were beginning to get wise to the hierarchical nature of the German decorative window scene, where a core group of established companies held virtual monopoly and tolerated competition from small, inconsequential projects only. Such limitation would always be a handicap and, to a man of Moje's resolute disposition, not one that even vaguely appealed. For the immediate future they were obliged by fiscal necessity to maintain the window commission work, but it was high time to mark some territory they could authentically call their own. Pulling the plug on the lagging

work, particularly the deeply carved, sculptural vessels, was so gratifyingly positive that they felt encouraged to apply for selection into the next exhibition round. They were accepted, but in truth it was too precipitous. Having insufficient work to fill a stand they scrounged around and supplemented the blanks with a weird conglomerate of wine bottles and laboratory glass. The resultant effect was unappealingly 'hippy' and wanly received. This would be their first and last professional miscalculation.

Despite the less-than-enthusiastic reception (and fully aware that the fault was entirely of their own making) they had nonetheless enjoyed the overall experience of exhibiting, especially in contrast to their growing distaste for the tendering process concomitant to the window commissions. The mental grind of peddling design ideas to pompous churchwarden committees of limited creative understanding was beginning to wear dangerously thin. Selling work on their own terms to a cultivated patronage was a far more attractive proposition. They went back to the studio with renewed vigour, ordering custom-made lead crystal blanks from the Hessenglass factory to push the carving even further, and began experimenting with lustre over-glazes; limiting the tones to red, green and blue and the decoration to a balanced, predominantly striped, restraint.

In 1967 they again applied for the craft show at the Museum für Kunst und Gewerbe and, happily, on this occasion the work drew universal and enthusiastic response. On the strength of the acclaim a colleague, ceramicist Monika Maetzel, offered them space on the windowsill of her stand at the Frankfurt Fair. It was a modest beginning that spring-boarded them into prominence. The trade fair, as always, was well attended by both national and international buyers and the Mojes'

glazier trade completely, they installed a linisher and a kiln and started to experiment with hollow glass vessels, grinding and painting the surfaces of blanks bought from local glass factories. Initially they were restricted by a paucity of tools and confined to techniques that didn't require a highly mechanised enterprise, but over time they steadily managed to replace and augment the equipment. When they were finally able to afford a new lathe Moje did the unthinkable – ordering custom-made diamond wheels to better suit his own requirements instead of working with traditional grinding stones. Up until then all diamond wheels were made to standard industrial settings and used for specific purposes only. The toolmakers were nonplussed, never having conceived of deviation from the industry norm, but Moje's persistence prevailed and ushered in the debut of a multi-purpose diamond wheel.

Ceramicist Bontjes Van Beck, who was then teaching at the Hochschule für Bildende Künste in Hamburg, turned up at the studio one day asking to have glaze drippings ground off a piece of pottery he was entering into the annual craft exhibition at the Museum für Kunst und Gewerbe. It was their first exposure to contemporary ceramics, and at Van Beck's invitation they attended the opening out of sheer curiosity. The show, a juried exhibition of craft practice across the greater Hamburg municipality, was dominated by high quality ceramics, with jewellery and textiles in respectable support. Glass was scant and hopelessly underwhelming, mainly beakers and basic overlays. But there was a *simpatico* crowd of enlightened and erudite people to meet, including the eminent gold and silversmith Professor Wolfgang Tümpel, a leading figure in Bauhaus circles. Some months later, during a visit to the Moje studio, Tümpel's critique of their developing

The Galerie der Kunsthandwerker, Danziger Strasse, Hamburg, showing an Ann Wärff exhibition.

painted glass attracted an immediate flurry of serious interest. It was a success borne of creative ingenuity. Ordinarily, enamel paint on glass vessels was applied in a prescribed manner and limited to decorative motif, but the Mojes' method of colour washing the entire surface was startlingly bold and fresh. While the Scandinavians used colour in blown vessels, nobody painted the surfaces like this, with a simplicity so finely in tune with the modern aesthetic. Most of the painting was done on a turning wheel and the repetition of the movement translated beautifully across the transluscent surface. The Mojes had themselves a 'signature'.

They were also becoming increasingly enmeshed in the craft community itself and taking a proactive interest in the (serially resurrected) art/craft debate. By 1969 Moje was a national representative of the World Craft Council and a seasoned campaigner for a contemporary craft movement that was fast witnessing a confluence of art and craft. This was a common goal of resolute pursuit, and evidence of the shift was beginning to resonate with a heartening surety. The Mojes were selected to exhibit at the School of Engineers' autumn exhibition at Gallery 66 in Hamburg, and at the *Triennale of European Decorative Art* in Stuttgart, where they picked up an award. By 1970 they had introduced engraving to the work – Isgard stippling the surfaces with decorative elements – and won another award at *Werkstoff und Form* at the Fockemuseum, Bremen.

The following year, they moved their workshop out of the old Glasschleiferei into premises on Danziger Strasse, which gave them the advantage of street frontage. Museums, educational institutions and trade-fair events aside, no system of craft galleries existed where makers could recurrently show their work. There were plenty of craft shops where one might

be offered a corner display (hemmed in by doilies and dinky folk art) but for the serious artist-craftsman this scenario was hardly satisfactory. The Mojes circumvented the dilemma by opening a gallery themselves, the Werkstatt Galerie, with an express intent to exhibit not only their own work but also that of others. It was a groundbreaking move in contemporary craft practice and set a precedent that others, emboldened, would soon follow.

The new workshop had the added bonus of a second kiln – one of the old ladies they were renting from had been a porcelain painter – and the extra capacity provided them the luxury of room to experiment in even more unconventional ways. By raising the firing temperatures until the forms began to slump in a nearly viscous state, the metallic salts in the glazes would penetrate more deeply into the ground surfaces, giving heightened intensity and brilliance to the colour. It was a dicey and costly process, and many pieces didn't withstand the heat. This slumped series, however, possessed an uncommon charm and was well received. (Except by the neighbours, perhaps, on the night of an overzealous reduction trial with naphthalene, which filled the five-storey residential block with the reek of burning mothballs.) Developmentally, this controlled slumping and warping of the perfect form was an important step – it was a deliberate distancing from the industrial norm, from the known and conventional. Although entirely unconnected, it is interesting to note the similarity of this work to the concurrently blown equivalent at the core of American studio-glass movement. The Mojes were, quite independently, addressing the selfsame aesthetic concerns.

Music still ranked high on the agenda, although Moje had reached a point where he would soon have to make a concrete decision about which career to pursue. The glass would win

1973

Untitled

carved lead crystal, lustre painted

18 x 10cm [dia.]

Moje grinding a mosaic cane bowl on the lathe.

out in the end. He was still passionate about singing and was a popular performer, but the repetitive nature of the gigs and touring was starting to kill the enjoyment. When visiting Prague in 1971 for the World Craft Council, which was also the first time he met glass artists Stanislav Libenský and Jaroslava Brychtová, he recalls ending up in the cellar of one of the castles singing all night with the Czechs. As soon as their minders had retired for the night, the artists took Moje to a hidden chamber stacked with revolutionary paintings that could only be shown to trusted friends when the officials weren't around. The whole episode was one of stirring camaraderie, strangely analogous with the aspirant struggle of the evolving glass movement itself – they were a band of insurgent brothers, pledging their loyalty to a nascent crusade! It was fitting, then, that this was also the year that the Mojes started to attract more formal acknowledgement for their work, winning the Hessen State Prize for German Decorative Art[5] in Frankfurt and the Hamburg State Award at the Christmas Fair.

Already the Mojes were widely represented in significant museum and private collections, and their glass had not only been accepted into the Rosenthal Studio Houses[6] but they'd been given *carte blanche* to send any work of their own choosing. This was unprecedented – ordinarily all pieces had to be submitted to a rigorous selection process by international jury. On the strength of the Rosenthal order, Moje travelled briefly to New York on a reconnaissance trip, and while there copped his first sighting of American studio glass – a Dale Chihuly/Jamie Carpenter collaborative installation of reeds – at the American Craft Museum. Hitherto his only point of contact with the American contemporary glass scene had been at the World Craft Council in Dublin the year before,

when he met Marvin Lipofsky. His exposure to the Americans would graduate by degree over the next decade, aided and abetted by a network of forums, at the centre of which sat the World Craft Council. The determination of this influential collective played a crucial role in the cultivation of a climate of mutual exchange and common purpose. The sense of purpose, in effect, that still forms the nucleus of studio-glass dogma today.

The year 1972 was one of progressive consolidation, with Moje being elected a Director of the World Craft Council for a two-year period, and the Werkstatt Galerie fast establishing a respected reputation for the promotion of innovative contemporary glass. Already they had shown the work of trailblazers Sam Herman, Erwin Eisch, Finn Lynggaard and Annette Meech, setting a benchmark for gallery practice that attracted the serious attention of curators and collectors across Germany. It was becoming a real frustration at the time, however, that far too much of his attention was being diverted away from the creative practice into the maw of the management and promotional side of the business. Little did he realise that he was on the threshold of momentous change.

The new year started with what had become the customary bustle. They exhibited in *Artist-Craftsmen in Europe* at the British Craft Centre, London; in *Leading German Craftsmen* at the third Primavera Exhibition in Cambridge, UK;[7] and won the medal at *Ceramic International* in Calgary, Canada.

And then it happened. On a regular visit to the Hessen Glaswerke near Frankfurt to pick up crystal blanks, Moje's eye was caught by a stack of coloured glass cane used in the manufacture of jewellery, buttons and chandelier lustres. It wasn't a new material – it had been on the market for years – but nobody had yet thought to use it for contemporary

5 At age 30 and 35 they were, incidentally, the youngest ever recipients of the prize.

6 Rosenthal, a manufacturer of fine porcelain, had set up 'studio houses' around the world which deal in contemporary craft deemed to be of the highest quality.

7 Curated by Henry Rothschild. The Mojes and Erwin Eisch were the only glass artists selected.

I first met Klaus in 1951 as a member of the 'Poseidon' swimming club. The two of us, in the spring of our lives, had two sisters for our girlfriends. We would escort them to swimming training and on long romantic walks. During this time together we grew to be like brothers. We appreciated each other. After 1952 we went our separate ways and I didn't hear from Klaus for a long time. We met again in 1965, when Klaus was married to Isgard and they shared a glass studio, and I was married to Karin and we had a ceramic studio. Both our workshops were in the same part of Hamburg, in St Georg. Immediately the old affection was there again. In 1971 Karin and I bought an old farmhouse in the country close to Hamburg and four years later Klaus and his family did the very same.

At that time it often happened that Karin and I would make work for exhibitions but then would be full of doubt about whether our pieces were up to scratch or worthy for display. That's when we would call Klaus. He would come over and take a critical look at the pots and his enthusiasm motivated us so many times to go on with what we were doing. In 1976 Klaus, Isgard, Karin and I got together with the ceramicists Barbara and Herman Stehr and the gold and silversmith Beatrice Polter to establish the Galerie der Kunsthandwerker in the old Moje studio gallery. The motivation and enthusiasm always came from Klaus. He did the photography and the invitations, and he had the press connections. He also had connections to artists from other countries. The rest of us were more in the role of helping him.

Dale Chihuly once came through Hamburg for a visit and in a few hours 30 enthusiasts had gathered in the gallery. Karin and I fetched chairs from the local pub, Klaus brought his projector and Dale gave a slide lecture. Everyone became a fan! The Galerie der Kunsthandwerker was very successful over a number of years and important for the craft scene in Hamburg.

When Klaus left for Australia in 1982 the gallery closed down. Even now when we stand in front of our new work and we are not that 'sure', we often wish we could give Klaus a call:

'Hey, come over here and look at our new pots.'

Walther Zander
Ceramicist

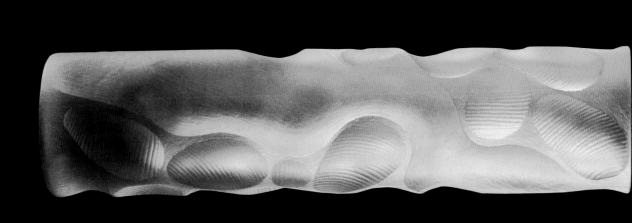

1974

Untitled

carved and engraved lead crystal

35 x 9cm [dia.]

work. Intrigued, he took a bunch of it home to experiment with. At this juncture he knew nothing of the ancient mosaic technique of the Romans, nor was he acquainted with the modern Italian, specifically Venini, blown equivalent. As there wasn't yet a fusing tradition to draw on, knowledge about colour compatibility and annealing requirements[8] was thin on the ground. Back in 1973 these really were unchartered waters. So Moje set about informing himself, and through a regime of meticulous investigation soon developed a new technique of his own devising.

Already having some idea of viscosity ranges from slumping trials for the painted vessels, he sliced up the canes on the diamond saw and laid them directly into a mould, covered by a 'lid' in order to high-fire them without the glass just melting into the centre. He later improved control of the fusing by laying the slices out, geometrically reconfigured into rounds, onto an asbestine sheet and pre-fusing them in the kiln. He then tried slumping these 'panels' into various moulds, and later grinding the surfaces in the manner of the crystal blanks. At every heart-cracking failure he would return again to the Hessen factory for yet another bundle of cane. In the absence of a pre-existing model, the identification of compatible cane and the unpredictability of the slumping and annealing behaviour dictated a painfully slow process of trial and elimination. Laborious though this may have been, it taught him the most invaluable of kiln-forming lessons: the importance of scrupulous precision.

The development stage for the new work would last for nearly two years and he wouldn't be ready to exhibit the first mosaic piece until 1975. In the meantime the Mojes were still making and exhibiting the painted works and Klaus was further progressing the sensual, deeply carved lead crystal

series. In 1974 they exhibited at *In Praise of Hands* at the World Craft Council, Toronto, Canada, and were included in *Six German Glass Artists*, hailed as a presentation of the work of the German glassmaking elite, which travelled from the Kilkenny Arts Week in Ireland to the Goethe-Institut in Munich, and thereafter to North and South America and Australia. The choice picks included Erwin Eisch, Hans Model, Reiner Model, Klaus and Isgard Moje(-Wohlgemuth) and Jörg Zimmerman.

In 1975 the Mojes moved into an old farmhouse on the outskirts of Hamburg and divested themselves of much of the Werkstatt Galerie's day-to-day managerial responsibility by turning it into a collaborative concern. They brought others on board, including ceramicists Karin and Walter Zander, Barbara and Herman Stehr, and the jeweller Bea Polter, changing the name to the Galerie der Kunsthandwerker to better reflect the expanded focus. In any event, the gallery, by this time well established, no longer required the same degree of promotional concentration. Moje was able to dedicate more time to the mosaic pieces he was now getting so close to resolving, having finally isolated a consistent, if limited, palette.

At last he had attained that solidity of colour he'd long yearned for, but the material itself, he soon observed, was actually offering him so much more. When sliced in the cross-section, the canes (made as cased overlays, pulled) revealed tiers of subtle shading not unlike rings of a tree trunk. As each cane had been individually made, some cased in double or triple layers of colour, or even a mix of opaque and transparent glass, the layering varied so much that it gave him an almost inexhaustible choice of assortment. Moreover his relationship with the material was evolving into

28

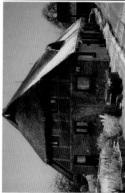

1975 The Moje farmhouse in winter.

Moje in his studio at the farmhouse.

8 Annealing is the slow and even cooling process that reduces internal stresses in the glass.

Untitled
carved lead crystal
10 x 15 x 15cm

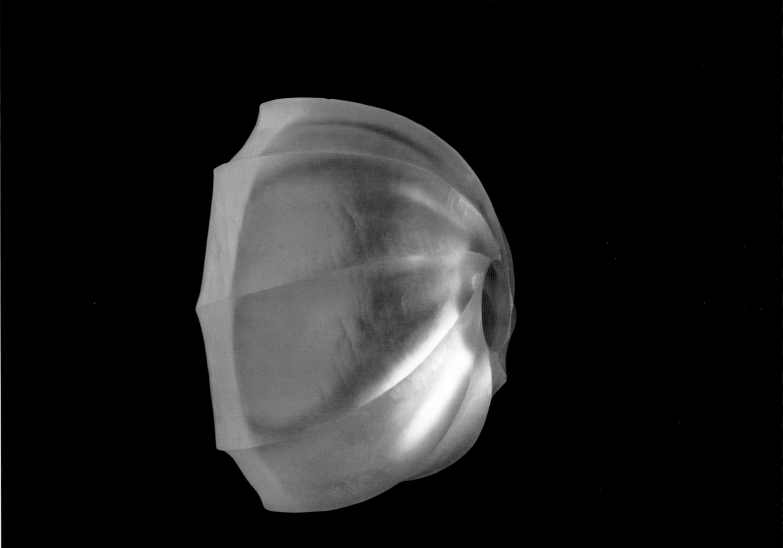

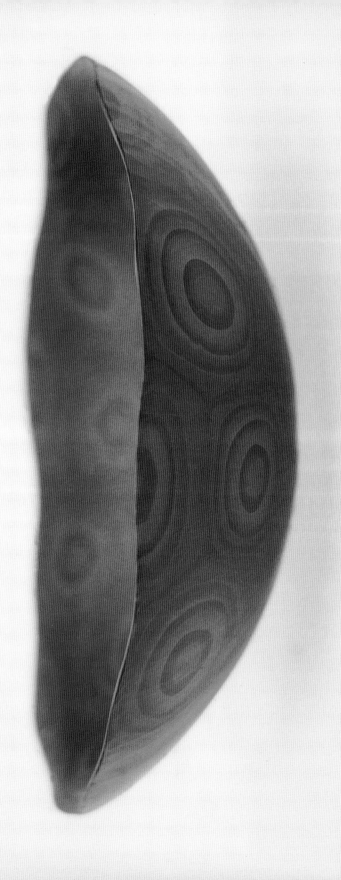

1975 **Untitled** 5 x 15 x 15cm

In 1996, in the year of his 60th birthday, the Museum für Kunst und Gewerbe in Hamburg presented, in collaboration with the National Gallery of Victoria in Melbourne, a retrospective exhibition of the glass artist Klaus Moje. The exhibition was named Klaus Moje: glass and one of the pieces on show was entitled New Horizons. Made in 1982, the title had a metaphoric meaning: it was the year that Klaus left the 'Old Europe' for the fifth continent, the natural beauty of which fascinated him from the first moment he saw it.

New Horizons is a kind of landscape painting in glass and at the same time it is a 'plus ultra', a new experience – venturing beyond the known to explore places as yet undiscovered. Klaus has always been a pioneer, someone who sees possibility and has the courage to pursue it.

Throughout his career Klaus has advanced from one success to another. As an apprentice he graduated as the 'Bundessieger'. After gaining his masters certificate he established his first workshop/studio in 1961 with his first wife Isgard Moje-Wohlgemuth. Their earliest commissions were church windows in painted flat glass. In 1966 they started to grind and paint vessel forms, and it was through these vessels that they became instantly recognisable and highly respected glass artists at the Museum für Kunst und Gewerbe's annual craft fair. It was typical of Klaus to always take on extra responsibilities. He started to accept voluntary commitments within the German Craft Organisations. Between 1969 and 1973 he represented the German Craft Organisation at the World Craft Council, travelling extensively. Klaus and Isgard also started a craft gallery.

Klaus first exhibited his kiln-formed glass made from fused and slumped canes in 1975, which proved to be a magic year. He discovered new ways to extend the technique, to gain new ways of expression, to compose signature glass surfaces. As guest teacher Klaus went to Pilchuck in 1979, became friends with Dale Chihuly and presented workshops and lectures in California, The Netherlands, England and Denmark. Also in 1979, thanks to Chihuly, one of his pieces entered the collection of the Metropolitan Museum in New York. One year later the Museum für Kunst und Gewerbe dedicated an extensive first publication to the work of Klaus and his wife Isgard. Klaus's plates and bowls in mosaic glass technique were exhibited around the world.

When Klaus in 1982 decided to leave for Australia one friend came to ask: 'Klaus why you are leaving from here at the height of your accomplishment?' But the scene in Germany had become too small for Klaus. He needed new challenges that equalled his generous thinking and his vision. At the Canberra School of Art he took on the position as founding Head and senior lecturer for the Glass Workshop. His work reacted spontaneously to the change of scenery. He used the colours of the land. A glowing, vibrant and sparkling colouration replaced the geometric strength that dominated in his late German work. In Australia he is still involved in crafts organisations, gives workshops and lectures, curates exhibitions and is forever advancing the profile of the crafts. Above all he is a passionate teacher who established a glass department of outstanding students. Equally important is his continual travel to the USA for a regeneration of ideas and technical experimentation. In the early 1990s he began collaborating with Dante Marioni in Portland to combine kiln-formed glass and glassblowing processes.

Very soon Klaus Moje will have his 50th anniversary as glass artist. The sum of his experience, the many people in the creative world he has met, and the sum of his exhibitions is unbelievable. His 1995 retrospective exhibition was seen in Australia, Germany and the USA, making him the very first glass artist from anywhere in the world wide to exhibit successively on three continents. Old and new techniques in glass have dominated his life. The craftsmen became a creator, the creator became scholar, the scholar became a teacher and educator, and all the while actively sought to explore and extend the technical and aesthetic possibilities of glass. Klaus is a spellbinding speaker whose ability to capture glass in words – so to speak – and to fill other human beings with enthusiasm, is legendary.

Wherever and however Klaus Moje has engaged with glass, he has always aimed for the new and widened the horizons.

Dr Rüdiger Joppien
Curator of International Decorative Arts
Museum für Kunst und Gerwerbe, Hamburg

one of palpable sensitivity; the more the glass revealed, the more he faithfully served it. He ground into the early thick, slumped vessels until he had exposed the full-blown beauty of the delicate striations, and in this he gained a certain feeling of privileged omnipotence. It was like he was breathing life into the material, which softened willing in his hands. The process itself was engrossing enough, but by now his intimacy with the material was deepening into such a tenderness that it would reshape forever his approach to his craft. The act of making would never again be merely an intellectual exercise; this had become an affair of the heart, with the glass his guiding mistress.

When he finally exhibited his first mosaic form at a group show in Hamburg, the piece, a white bowl, caught the attention of Alex von Saldern, Director of the Museum für Kunst und Gewerbe, who purchased it on sight for the museum collection. Moje modestly refers to this as 'beginner's luck',[9] but it was certainly incentive enough to continue the mosaic line. He had found a way of using colour that was finally truly satisfying for him. That it immediately struck a chord with the wider public was an added bonus. On the studio front, however, it wasn't an entirely comfortable transition. The diamond saw, horrendously noisy, had to be run outside and the dust from the grinding affected Isgard's painting, obliging them to work more often than not at different times of the day. He was still carving the crystal vessels and grinding the surfaces in preparation for Isgard's painted forms, but while they both continued to exhibit jointly for another five years, in essence their practices from this point imperceptibly began to diverge. Having uncovered a visual language of his own, Klaus was compelled to give it voice and fluency.

In 1976 the Mojes won the Bavarian State Award in Munich.

This was also the year that the Museum für Kunsthandwerk in Frankfurt held the first significant exhibition of international glass to be shown in Europe.[10] *Modern Glass Made in Europe, USA and Japan* was Moje's first introduction in person to Dale Chihuly, Joel Philip Meyers, Stephen Procter and Kyohei Fujita, among others. It was a milestone in the continuing amalgamation of the international studio-glass scene, but more importantly, it was the beginning of many close and enduring friendships.

There did exist, though, an estrangement of a distant-cousinly kind between the (predominantly) American glass-blowers and the European masters. The blowers, gung-ho and spontaneous, regarded the deliberative work of craftsmen like Moje as technical exercises of a dull and sedentary nature. In that hip post-*Easy Rider* era, 'kiln' was a four-letter word and 'skill' a nerdy encumbrance. The status of Moje as the prophet of a visionary movement within the contemporary glass revolution was as yet largely unappreciated. Chihuly (himself a symbolic phenomenon) was the exception, having a healthy respect for the symbiotic dependency of tradition and innovation, and an unerring eye for 'the real deal'.

Back in 1968, as a Fulbright Scholar, Chihuly had not only become the first American glassblower to work on the Venetian island of Murano, but had followed that up with a pilgrimage of sorts around the studios of Erwin Eisch, and Stanislav Libenský and Jaroslava Brychtová. His sagacious vision of the trans-Atlantic nexus was vital not only to his own studio practice but also to the developing prosperity of American glass at large. Indeed it underpinned the philosophic impetus behind the founding of the Pilchuck Glass School in 1971 – a place where the spirit of exchange between the old world and the new would be fortified even further. Moje would be

9 Klaus Moje, in interview with Megan Bottari.
10 There was an exhibition, *Today's Glass: Art or Craft?*, held in the Museum Berrerive in Zürich in 1972 in concert with the World Craft Council gathering, but it had been limited to blown glass only.

Moje with Harvey Littleton at the World Craft Council, Oaxtepec, Mexico, 1973.

Moje and Chihuly having fun at Pilchuck.

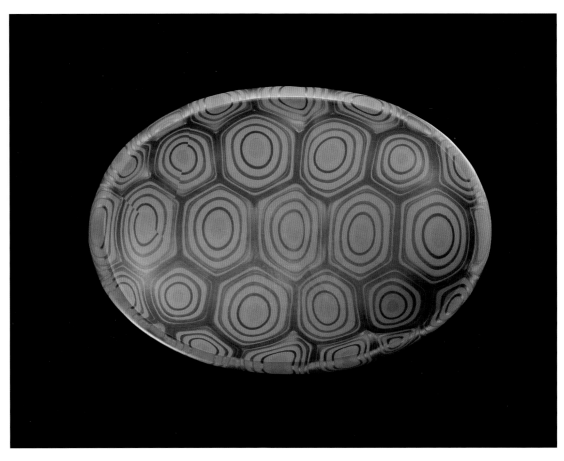

33

1978 **Untitled**

4 x 22 x 16cm

Collection of Susanne Steinhauser and

Daniel Greenberg

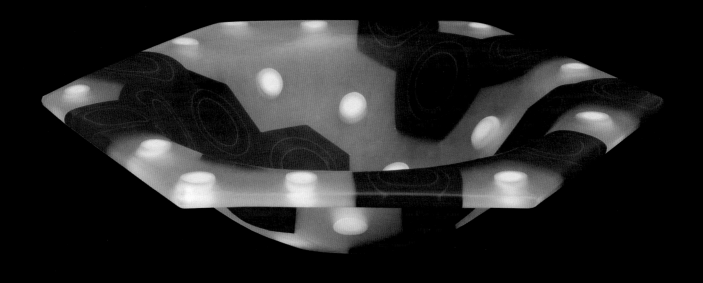

1978 | **Untitled**

4.5 x 25 x 25cm

Collection of the Kunstmuseum, Düsseldorf, Germany

Gift of Ann Wärff

1979 **Untitled**
 5 x 28 x 28cm
 Collection of Corning Museum of Glass, USA

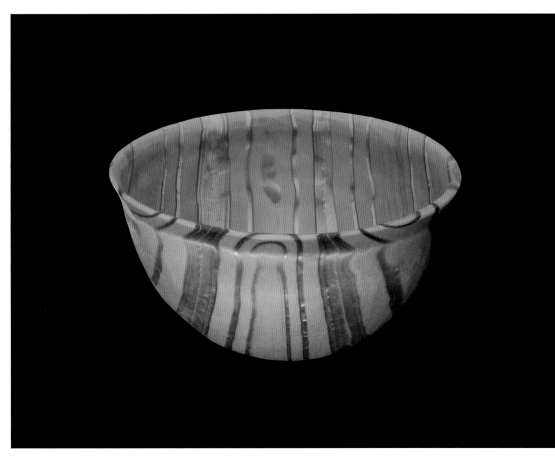

When I met Klaus Moje in 1979 in Pilchuck,
I knew only a little about his works, although I
had seen and admired them in a Corning review.
I must say that I liked them very much, even
though I compared them with Venetian murrine
bowls. Shortly afterwards Klaus moved to
Australia where he changed and raised the
level of quality of contemporary glass practice.
As a teacher he transformed his school in a
single move. In Australia, he truly exploded with
imagination and force, which was exceptional
to witness. I must say that his artistic maturity
literally stunned me. It was incredible, with
powerful, resolute colours, full of light and
uncomplicated. I admire Klaus's desire to live
the 'cult of friendship'. Time flies but Klaus
always remains a good friend.
 With affection and friendship.

Lino Tagliapietra
Maestro

1979 | **Untitled**
4.5 x 11 x 11cm

another of the European masters introduced by Chihuly, via Pilchuck, to the vibrant American scene.

Also in 1976 Klaus and Isgard attended the glass symposium at the World Craft Council in Oaxtepec, Mexico, mixing once again with an august assemblage of internationals including not only practicing artists – Harvey Littleton, Alberto Barovier, Marvin Lipofsky, Bert van Loo, Jack Ink and Patrick Reyntiens to name but a few – but also associated glass 'heavies' such as Thomas S. Buechner, the President of Steuben Glass, Corning. The stamp of the gathering was the spirited debate and critical exchange, and the due weight given to the perennial, cardinal issues of skill, education and integrity to craft. Moje was starting to manifest an inkling of a vocational bent towards teaching.

The following year the Mojes were included among the finalists of the Coburg Glass Prize alongside entries from America, Europe and Asia. Indeed they had become so synonymous with excellence in German crafts that 'Moje glass' was becoming the state gift of choice for visiting dignitaries. Moshe Dayan, the famed Israeli Foreign Minister and former commander of the Israeli army, and his wife were presented with a Moje piece on the historic occasion of their first visit to Germany: 'the first time the Star of David flew over the Hamburg Rathaus-Portal'.[11] On other occasions recipients included the wife of the Portuguese Prime Minister, the Chinese Deputy, Fang Yi, and any number of European political luminaries besides. The Moje patronage base was patently solid.

From now on, frankly, there was virtually no exhibition of any significance that the Mojes weren't included in, but of particular note are German Glass Today, Interversa, Hamburg (1978), which later travelled worldwide, and New Glass – A Worldwide Survey at the Corning Museum of Glass, Corning,

USA (1979). The Corning exhibition featured two mosaic pieces and represents the demarcation point after which Moje works and exhibits exclusively in 'Klaus Moje mosaic' only. The official finale of the Moje studio partnership would follow in 1980.

In 1979, Moje[12] taught his first session at Pilchuck, a casual arrangement that settled into an association of some 25 years duration. It was an introduction, however, of only qualified success. While he found the concept, the philosophy, of Pilchuck exhilarating (namely, a strategically isolated campus dedicated entirely to the cult of glass) the lack of facility for his particular technique was a disappointment. Not that he had gone there unaware of the eminence of the hot-shop – goodness knows blown-glass was the raison d'etre of the American glass movement – but the total lack of cold-shop equipment was a hindrance he had not anticipated. Nonetheless, he joined happily into the famous Pilchuck spirit of improvisation and demonstrated as best he might (he'd brought his own cane, which Pilchuck supplemented with some Kugler colour rods[13]) but the inability to finish work to any acceptable standard, let alone his own, did not sit comfortably with him.[14]

That same session also marked the Pilchuck debut of Lino Tagliapietro, the Venetian glassblowing maestro, and heralded the beginning of the tsunami of Venetian influence that still dominates contemporary blown glass today. Up until then the Swedes had held stylistic sway at Pilchuck, and Moje was a fascinated witness to the shift that played out on the hot-shop floor. There'd been a machismo stand-off between the austerity of the Swedes, the freestyle antics of the Americans and the exquisite opulence of Tagliapietro – each eyeing the other off from different corners of the pad – until the 37

11 Hamburg Abendblatt, Monday 28 November, 1977.
12 Isgard also taught at this session.
13 To the horror of the blowers, who regarded it a profligate waste of precious colour bar.
14 The kiln and cold-working facilities improved progressively over the years.

slow dawning of a begrudging respect for the sheer *virtuosita* of the Italian's skill. It was the first step towards the reinstatement of 'technique' in the studio (blown) glass lexicon.

A rash of other teaching jobs followed over the next couple of years, at the Arts and Crafts School, Copenhagen, the Royal College of the Arts, London, the Middlesex Polytechnic, London, the California College of the Arts and Crafts, Oakland, the Rietveld Academy, Amsterdam, and, of course, at Pilchuck (repeating). In fact, he was developing something of a missionary zeal that went beyond the sharing of his own technique. The ascendency of contemporary glass was, at the time, being massaged by a spate of glass programs mushrooming up in universities and colleges across the globe, but Moje was becoming increasingly concerned about the lack of formal craft training underpinning any of the courses. As soap-boxes go, this was custom-built.

Moje's mosaic work, meanwhile, was developing apace. He had broadened the motif options by slicing the cane lengthwise, introducing the stripe to his patterning repertoire, and the widening, framing rim. It has long been generally supposed that various modern art movements influenced Moje's practice, but truth be known he's never allowed outside influences to interfere with his work. His muse has always been the material – and anything that we, the viewer, may read into a piece (whether the painterly quality, or the contexture of soft, washed silk) Moje himself has divined directly from the glass itself. So it was a loss of some magnitude when the resident cane-maker left the Hessen factory, taking with him the precious recipes for this particular variety of glass.[15] Suddenly Moje was left with a finite resource and no comparable substitution. Not that he didn't have tonnes of the stuff in stock, having bought up all that was left, but it meant that as he ran out of certain canes, particularly his favourites, it would signal the end of a run of work. Those gorgeous soft shantung silks were the first to go, and bade goodbye with much regret.

In 1980, under the direction of Axel von Saldern, the Museum für Kunst und Gewerbe presented the *Isgard Moje-Wohlgemuth and Klaus Moje Glass* retrospective exhibition. Though not the case when the show was curatorially conceived, by the time of the opening the Moje partnership had been dismantled – turning the event into an unwitting though rather suitable commemoration of a vanguard period in contemporary German glass. For Moje, the impresario, it was the end of a chapter only.

Through his ongoing ministrations, the Galerie der Kunsthandwerker would continue to play host to the cream of the contemporary glass scene – Chihuly, Billy Morris, Anne Wärff, Flora Mace and Joey Kirkpatrick, *et al*, the majority of whom he connected with at Pilchuck – while his own exhibiting commitments also showed no break in stride. Moje's most prestigious exhibition that year was *Contemporary Glass – Europe and Japan* at the Museum of Modern Art, Tokyo and Kyoto, Japan. He commenced, in addition, his long association with both the Heller Gallery in New York and Habatat Galleries in Detroit and Miami, with the first of a continuing list of exhibitions.

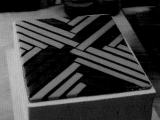

15 Traditionally these trade 'secrets' were handed down from father to son and the property rights fiercely protected.

1979 | Laying out the patterning for a mosaic cane form. | The fused panel prior to slumping.

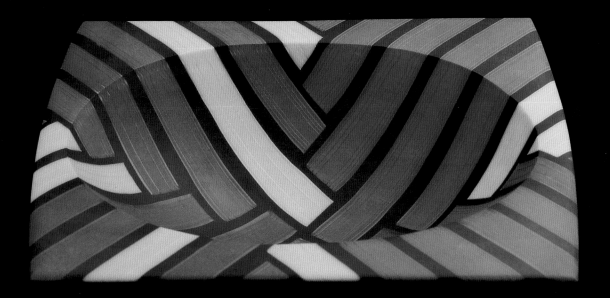

1979 **Untitled**
7 x 31 x 23cm

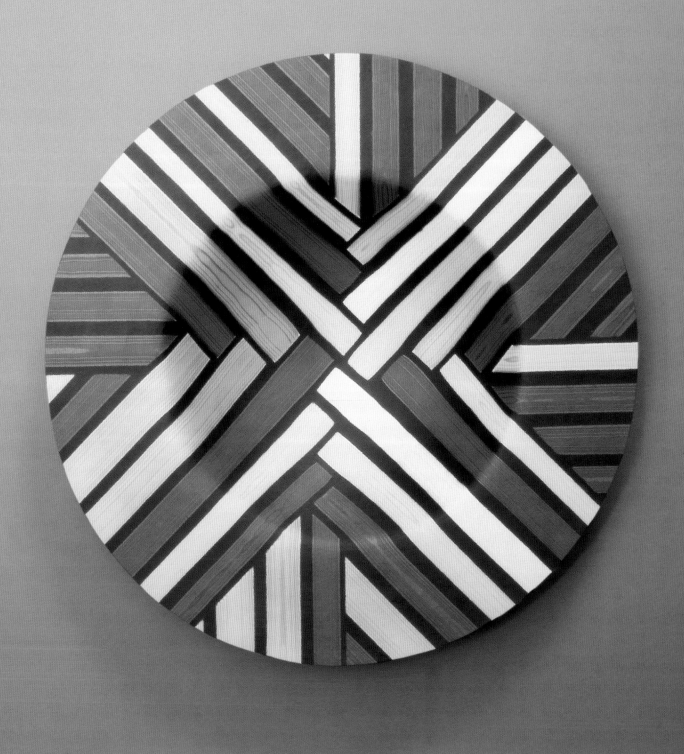

1979 | **Untitled**
5 x 46 x 46cm
Collection of the Metropolitan Museum of Modern Art,
New York, USA
Gift of Heller Gallery and Dale Chihuly

But the greatest signifier of the time emerged during a teaching sojourn at Pilchuck, where one of his students was Boyce Lundstrom, co-founder of the Bullseye glass factory in Portland, Oregon. Following discussions about the technical difficulties Moje was having with German glass (most specifically the palette and compatibility issues) Lundstrom invited him back to Bullseye, both to visit the facility and to meet his principal partner, Dan Schwoerer. Inspired by Moje's technique, and empathising with the handicap of material restriction, they promised that they would develop and deliver him a complete colour palette of compatible glass. He famously thought at the time: 'These big-talking Americans! In Europe the glass factories have been working on these problems for hundreds of years and these guys want to do it in no time!'[16] Precisely two years later a crate of Bullseye glass, stamped 'tested compatible', landed on his doorstep in Hamburg. He would never look at another material again. In the meantime, Moje was obliged to continue the persistent ascension of his successful practice regardless.

By 1981 he was literally exhibiting back-to-back: in solo shows at Foster/White Gallery in Seattle, Habatat Galleries in Detroit, Heller Gallery in New York, the Galerie Lietzow in Berlin, Galerie 'M' Gottschalk in Frankfurt; and group shows in Germany, Japan and Alaska. It had already been a relentlessly buoyant and gratifying year when out of the blue came a *coup de grâce*. Moje received a phone call from Udo Sellbach, Director of the Canberra School of Art in Australia, who was conducting an international search for a suitable founding Head of the school's embryonic Glass Workshop. He was travelling to Germany, and would like to meet. For Moje, the possibility this presented was both startling and intriguing.

41

1981 Boyce Lundsroem (left) and Dan Schroewer at the Bullseye Head Office, Portland, Oregon, USA.

Daughter Mascha holding a mosaic piece.

16 Klaus Moje, in interview with Megan Bottari.

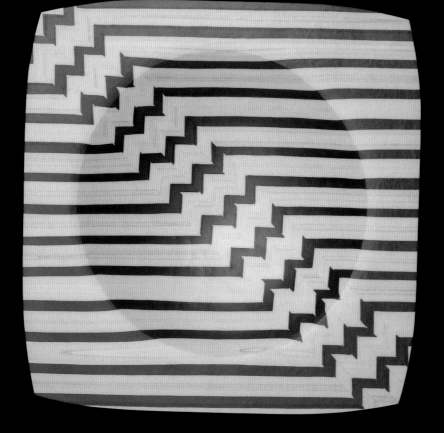

1981 **Untitled**
7 x 34 x 34cm

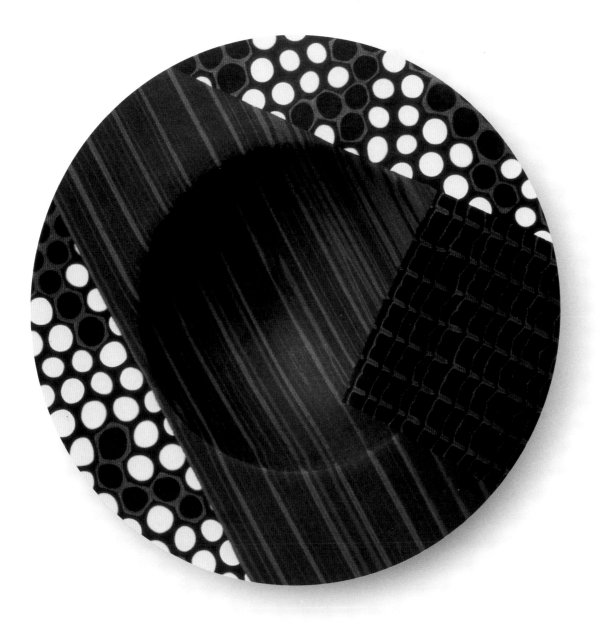

1982 **Untitled**
7.5 x 48 x 48cm

My professional relationship with Klaus Moje began in 1980. As someone who had been interested in antique and ancient glass I immediately responded positively to his work, seeing it as a contemporary art statement utilising the ancient Roman technique of Ribbon Glass. Moje's palette was chromatically bold and his compositions displayed a crisp complex geometry. It was fully mature original work unlike any other the gallery represented. That year Klaus was featured in a three-person exhibition in our gallery along with Dale Chihuly and Ann Warff (now Wolff). At the time, Penelope Hunter Stiebel, curator of 20th Century Decorative Arts at the Metropolitan Museum of Art, coveted one of Klaus's exhibition pieces for the Museum's collection. As is often the case the curator lacked acquisition funds. So, in partnership with Dale Chihuly, the gallery donated a large striped platter to the museum.

Over the years we have repeatedly had the pleasure of placing Moje's works in significant private and public collections including the Museum of Arts & Design in New York, the Chrysler Museum of Art in Norfolk, Virginia, and the Racine Art Museum in Racine, Wisconsin.

In 1986 John Schlesinger, the noted film director, acquired a Moje piece and had it shipped to where he was on location so while he worked he could be 'surrounded by the beautiful things he loved'.

Barely two years after our first gallery show Klaus made plans to relocate from his native Germany to Australia where his profound impact as both teacher and studio artist has been well documented. A gifted artist and a meticulous master craftsman, he has also been a generous teacher and mentor to innumerable young people aspiring to work with glass. The many honours that have been bestowed upon him are a fitting recognition of the contributions he has made in an illustrious career that has spanned nearly half a century.

Now 70, Klaus Moje is creating art that is still conceptually evolving and his highest achievements may yet be in the future.

Doug Heller
Director of Heller Gallery, New York

1980 **Untitled**
7 x 31.5 x 25cm

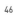

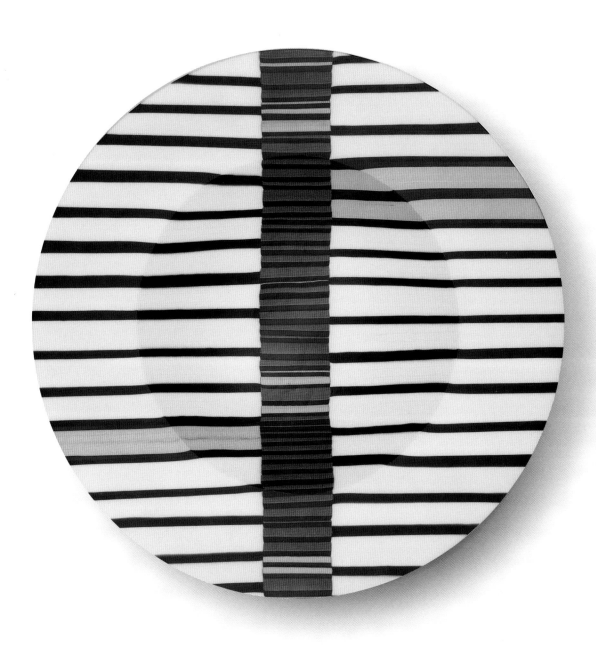

1982 **Untitled**
7.5 x 38 x 38cm
Collection of Hokkaido Museum of Modern Art, Japan

1982 **Untitled**
7.5 x 38 x 38cm
First experimental piece made with Bullseye glass

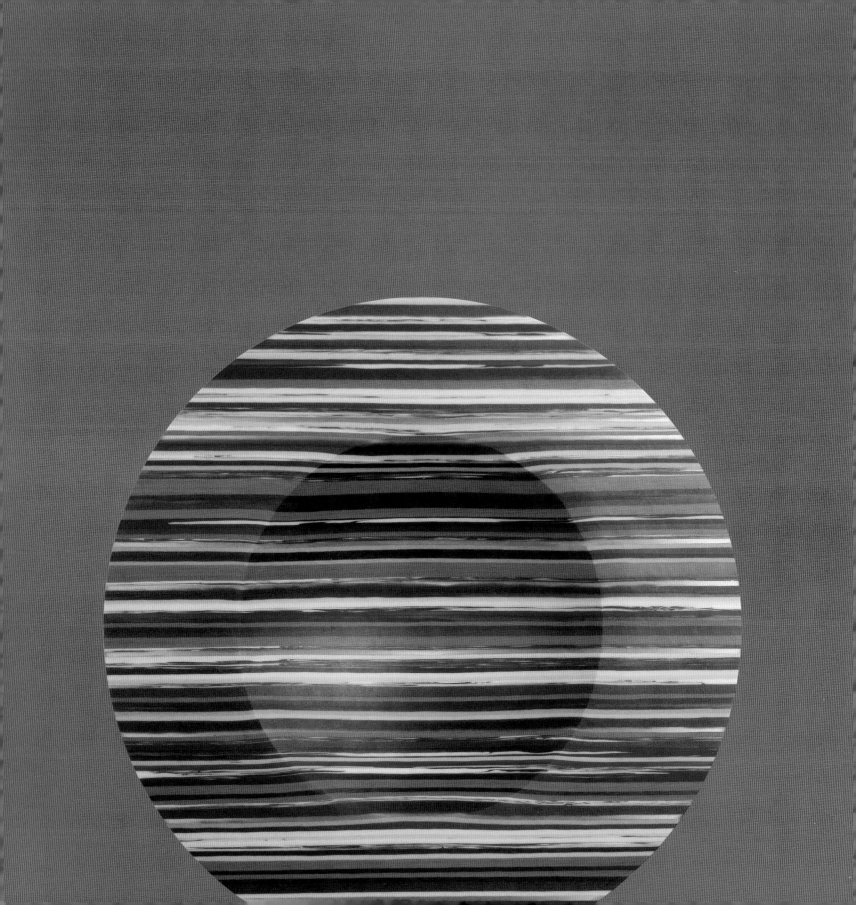

Act Two: The New World

do Sellbach was also a man with an educational mission. His working brief as Director of the Canberra School of Art,[17] newly relocated from Kingston to its present location in Childers Street, Acton, was to establish an institution of international stature. It was a goal achievable only, in his view, through a curriculum built on a high-calibre craft foundation. In this he aligned himself with the Bauhaus dictum of drawing no distinction between the fine and applied arts. As construction on the school buildings neared completion, he turned his attention to the vital question of the requisite faculty. The school, structurally modelled on Bauhaus principles, would consist of a complex of individual workshops, each headed by an eminent master artist-craftsman. Sellbach, having come from a background of European art training himself, had been on the lookout for candidates of empathetic principle and impeccable credentials. The majority of the Head of Workshop positions were already filled and functioning, but the new glass program was as yet an empty shell with no determined focus, a circumstance that required careful deliberation given the budgetary constraints on the education purse. Sellbach had been canvassing members of the fledgling Australian glass community for advice, and for a period of time had circled the prospect of enlisting the American glassblower Dick Marquis[18] whom he also greatly admired intellectually. But the initial assumption that the workshop would be a state-of-the-art glassblowing facility needed to be re-evaluated once the final cost estimates started to come in. The hot-shop component was subsequently radically down-sized.

Sellbach needed to find another hook to hang the school's reputation on. The alternatives were Euro-centric and traditional – though enquiry did lead him to the stir being generated by a new technique called kiln-forming. Its leading proponent was a certain contemporary German glass artist who was, by all accounts, a master craftsman of significant repute. Information being limited (courtesy of the ubiquitous tyranny of the Australian distance) it was a possibility that plainly demanded closer investigation. The Department of Education sent him abroad with a head-hunting list, at the top of which was pencilled Marquis in California and Moje in Germany. Travelling via America, he first visited Marquis whom he found to be exceedingly helpful, though disinclined to take the job himself. Their lengthy discussions, however, confirmed Sellbach's growing conviction that the new facility would best be served by an artist whose skill-base bridged both hot and cold techniques. The vast majority of glass programs at that time, world-wide, were heavily focused on the hot-shop, and Sellbach was quick to comprehend that a dimensional shift in workshop emphasis would deliver Canberra both a unique curriculum and the strong craft fundamental to sustain it.

He flew from sunny California into a snow-bound German winter and drove coatless and cold to the outskirts of Hamburg in search of the Moje address, which he found on arrival to be a lovely old thatch-roofed farmhouse as charming as the hospitality within. He was ushered inside by Moje's new companion, ceramicist Brigitte Enders, and spent an enjoyable evening made all the more comfortable by an instant rapport with his host. Sellbach could sense immediately that he'd found what he was looking for: the manifest master craftsman who could deliver not only his own expertise but straddle the broader glass picture with comfortable authority. Moje, though not a glassblower himself, nonetheless had a working familiarity with the hot-shop and a genuine respect for his hot-glass colleagues. But the real clincher was Moje's vocational bent. Having observed and taught in both

The Canberra School of Art,
Australian National University.

17 Udo Sellbach had been Director since 1976, and had overseen the transition of the art school from its old digs in Kingston to the newly renovated campus at Acton. The school is now officially called the Australian National University School of Art.

18 Sellbach had met Marquis in Hobart at the Tasmanian School of Art, when Marquis was working with Les Blakebrough prior to returning to America.

51

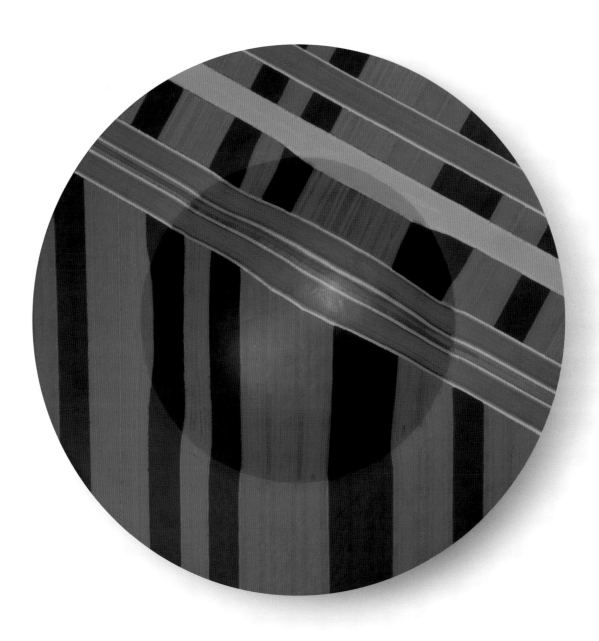

1981 | **It's Blue**

7.5 x 48 x 48cm

Collection of the Art Gallery of Western Australia, Perth

This cane mosaic, travelling separately to Australia, was the first Klaus Moje piece to be exhibited in this country. Moje himself arrived soon after to take up his position as the founding Head of the Glass Workshop at the Canberra School of Art.

I have been aware of Klaus Moje for about 30 years now. From the beginning his style has been so distinctive that once seen it is never forgotten. One remembers it above all for its lively treatment and arrangement of colour. Very soon after graduating from the glass school at Rheinbach and Hadamar he made it clear that he was going to use the cutting skills he learned there to go his own way. It is, however, characteristic of him that he did not abandon what he had learned. His respect for skill made him cherish tradition while becoming his own person in glass. It is this sane approach always tempered with something just a bit bohemian that makes his work so engaging. He revels in the sexiness and the joy of colour and as a colourist he has no inhibitions. His colours sing and dance with great ease belying the enormous craft disciplines that give them such freedom.

Our paths have not crossed all that often. I think the first time I met him was during the 1980s in Canberra. While he is photogenic, he is much more fun than his portrait photos suggest, easy to be with and immediately welcoming. Perhaps that is what makes him such a good teacher. At a North Lands masterclass in 2004 I observed him with his students. He didn't say a whole lot, but friendly body language and an expressive face are what count with Klaus. He only says what really needs to be said. It is his way of commanding respect and of respecting others, whether students, fellow artists, friends or colleagues of any sort. It helps that he is tall, which makes his presence commanding.

Life in Australia and growing older have definitely loosened him up as an artist. The linearity of his early days has mellowed and become wilder. The straight lines and hard edges of the 1980s have given way to something much more expressive. In the 1990s his work lost its stiffness, in part due to the amazing collaboration with Bullseye for whom he has done so much and who have done so much for him as a colourist seeking flexibility and freedom. Between them, Lani McGregor, Dan Schwoerer, the Canberra School of Art Glass Workshop and Klaus have opened doors to a new landscape in glass for himself and for future generations. All in all Klaus has done a great deal for his art form as a teacher, as an engaging personality, as an Australian icon and above all as one of the great contemporary talents in glass.

Dan Klein
Writer and freelance curator of contemporary glass

I first met Klaus Moje in 1981, when, as the Director of the Canberra School of Art, I travelled to America and Europe looking for a suitable candidate for the position of founding Head of the new Glass Workshop. In Australia I only had limited information about him but I had seen his work and knew of his reputation. The trip to Germany, to his home outside of Hamburg, confirmed at once his suitability for the position. We understood each other from the outset and I knew that I wasn't with a person who wanted, who needed, to rise to compete with others. That is when I learned that he was actually a master! He was a master who luckily combined hot and cold glass – because, although he didn't blow glass, he was familiar with it, he had the background, and to him it was part and parcel of the one thing. He had a good historical background, he was recognised internationally and he had very strong American connections. I knew that I was on to a person who could be a leader rather than just a local master, a leader who could actually be influential for the whole glass movement. He was exactly what I needed for the school that I was building. He got the job. One thing about Klaus from the beginning was that you understood that he knew what he was doing. He wanted the best and he wasn't just dreaming of it, he was doing it. That for students is quite exciting because they can sense the total commitment – something with a proper background, not just something picked up. It produces a very sobering but encouraging image. I remember how delightful it was to see the material itself so sympathetically and lovingly handled and prepared.

Udo Sellbach
Founding Director of the Canberra School of Art
(Extract from interview with Megan Bottari)

European and American glass schools, he had developed very strong views apropos art-craft training, favouring a well-structured, holistic approach – something that struck precisely the right balance between the rigid European technical instruction and the blithe conceptualism of the Americans. Technique and concept, while inseparable, needed to be harmoniously managed. Sellbach and Moje were on a wavelength. Returning to Australia, Sellbach reported his findings to the department and Moje was offered the job.

From Moje's perspective, although this was a bolt out of the blue, it wasn't an unwelcome one. At that precise moment in time he had a genuine sense of being at the pinnacle of his career: a 20-year practice behind him, accolades aplenty and as much prestigious patronage as he could possibly handle. Consequently he was open to the idea of a 'sea-change', particularly one that plucked at his ethical Lutheran imperative to 'give something back'. The contemporary glass movement's ethos of exchange was something he'd already long subscribed to and Sellbach's proposition had, in effect, struck an already resonating chord. In every teaching situation he'd encountered he had found something wanting – a lack of technical knowledge here, a narrowness of focus there – and so this offer to establish, from scratch, a curriculum that redressed these imbalances was almost irresistible. It was also a huge commitment and one that he was loath to make alone. The seal on the deal, in fact, was Enders's willingness to go with him, which had a happy, dual purpose of cementing their relationship as well.

While Sellbach was raising funds back in Australia to help pay their shipping costs, Moje and Enders set about the burdensome task of winding down commitments and packing up their lives for the wholesale move to the antipodes. With no preconceptions of Australia beyond impressions of beautiful water, the prospect of diving, and enchanting notions of Aborigines and the outback that Moje had gleaned from a book as a 10-year-old boy, they naturally had a mounting sense of great adventure. There was still plenty of 'business as usual' to attend to first: a *World Glass Now '82* exhibition at the Hokkaido Museum of Modern Art, Sapporo, Japan; a solo show at Habatat Galleries, Michigan, USA; a solo exhibition at the Galerie SM, in Frankfurt (which in effect would now be his farewell show in Germany); and sessional teaching at Pilchuck in July; following which they would travel directly to Australia.

In the midst of all the intense activity came the utterly unexpected – the (aforementioned) crate of sheet glass from Bullseye. Astounded, Moje dropped everything to give it a try – not with intent to show any pieces yet, but just to taste-test the material – and immediately he could see the potential. 'The boys' from Bullseye had delivered on their promise, and for Moje it was the beginning of the journey to glass nirvana. With the benefit of hindsight, the sell-out show at Galerie SM would now represent the apex of Moje's mosaic period in cane – the arrival of that Bullseye crate being the harbinger of swing in the Moje oeuvre. In one final act of disengagement they dispatched the two shipping containers that carried the (culled) sum of their worldly possessions: one packed with furnishings and domestic goods, the other with their respective ceramic and glass workshops. Separately, a mosaic piece had already been sent ahead to the Art Gallery of Western Australia for the travelling exhibition *International Directions in Glass Art*, curated by Robert Bell, which would open in Perth just prior to Moje's own arrival from America.

It's Blue (1981) was the title of that first Moje work to be

1982 **'New Horizons'** series
7 x 48 x 48cm

exhibited in Australia, and in all likelihood presupposed his first spoken reaction to the gloriously cloudless sky that welcomed them to Sydney. They had a connecting flight booked to Canberra but were so besotted by the sunshine and the heavenly scent of frangipani hanging in the air that they decided instead to send the luggage on by plane while they hired a car for a leisurely drive through the country. On arrival, of course, they got hopelessly lost in Canberra's infamous riddle of circular roads and it was rather late in the day by the time they found the school, which by then was in a state of terrible uproar. Brigitte and Klaus were missing! Only their luggage had arrived on the morning plane! (How quaint they were, seemed to be the general consensus of opinion, to drive when they could fly.)

They would be obliged to find their own housing at the earliest convenience but for the time being were accommodated in one of the school flats. Their first waking impression of Canberra was of magpie melody and that incredible clarity of air, but thereafter experienced something of a culture shock. Initially Moje was quite horrified by the artificiality of the city, designed only as recently as 1912 by Walter Burley Griffin. 'The uniformity is unbelievable,' he told *American Craft* in 1984, 'even the lake is artificial.'[19] And by the apparent lack of street-life. After Europe it must have been quite bemusing to find the civic centre so empty and restaurants closed on Sunday nights. They soon learned the ropes, once they realised that Canberra had quite a vibrant scene spread out across satellite suburban precincts – it was just a matter of being 'in the know'. The big disappointment was the immutable fact that Canberra was no closer than Hamburg to the sea. They eventually found a house to rent in the suburb of Watson and bunkered down.

Moje had arrived in August with just six months in hand to prepare the workshop for the beginning of the next academic year. The new building, located in the very centre of the school, was a big empty space with an exceedingly large and expensive hot-shop-specific exhaust system, a hangover from the premature planning stage.[20] The fit-out would be straight-forward enough once the shipping container with Moje's equipment arrived – the added advantage of his appointment being that he would bring all the requisite tools and specialist machinery with him. But of course Murphy's Law of Shipping prevailed and they were beset by a series of customary obstructions, first on the wharf and again at the quarantine depot at Fyshwick.[21] Frustration notwithstanding he used the interim wisely, making introductory overtures to regional craft and cultural entities and familiarising himself with the schematics of the Australian contemporary glass scene. Despite their movement being barely a decade old, he found Australian glass practitioners to be keenly proactive and, through the professional association AusGlass,[22] very effectively networked.

Having thus sourced his operational tool of choice, the connective interchange, Moje began to cast about for a suitable candidate for the associate staff position, somebody able to assist in the implementation of the curtailed hot-glass component of the program. He consulted widely and travelled to Newcastle to meet Julio Santos, who was considered the pick of the practicing glassblowers at the time. Then at an AusGlass meeting in Sydney he met an interesting young man who had only recently returned from the New York Experimental Glass Workshop. Neil Roberts had completed his traineeship at the JamFactory in Adelaide, and then studied at Orrefors in Sweden prior to the gig in New York. He was essentially a visionary with 'street cred', which struck Moje as precisely

55

19 In interview with Paul Hollister for 'Klaus Moje', *American Craft*, December issue, 1984, p 22
20 This would remain, an obtrusive and superfluous presence, until finally removed in 1987 when mezzanine offices were built.
21 An industrial area of Canberra.
22 Founded in 1978, the association was an initiative of Sydney glass artist Maureen Cahill, and originally had the amusing moniker PIG: People in Glass.

the right kind of balance and style for an aspirant and innovative program. Roberts subsequently moved to Canberra to help with the ongoing preparation of the school studio. Where, to the great relief of all, the imported equipment had finally been accessed, unloaded, and installed to optimum strategic advantage, with due regard to the future development of the remaining workshop.[23] The noisy diamond saw had been sensibly immured in a small room of its own. Moje was now left with only two pressing concerns vying for his attention: the arrangements pertaining to the program itself and that beckoning, teasing crate of Bullseye glass.

Sellbach, to all intents and purposes, had given Moje free reign with the content and structure of the course, and Moje was very keen to stamp it with his own brand of 'practical theoretics'. The program would by definition be configured to the standard tertiary parameters – a four-year Bachelor of Visual Arts degree and a two-year diploma – but that was about as conventionally corseted as it would get. While he and Sellbach were in perfect accord with the Bauhaus tenet of 'truth to material' and art/craft interdependency, Moje however didn't subscribe to the Bauhaus cult of personality.[24] The very thought of producing an alumni of obsequious replicants was, and remains, anathema to him. Nor would he teach by project or rote. He would lead by example, certainly, and cultivate a climate of rigorous critical exchange, but creative resolution, he firmly believed, would always require both feet and intellect planted squarely on the workshop floor. He was also adamant about effective student/teacher ratios, citing the self-evident qualitative relationship between capacity and teaching contact. He insisted on an intake of only four students per year for the degree course (which would amount to a full-house of 16) with extra allowance for two

diploma students, giving the facility an 18-student maximum. *In toto*. This was a standard that he fought the bean counters hard for, and won. It is arguably one of the most crucial factors at the root of the Canberra School of Art Glass Workshop's near immediate success and impact. From that first intake of four, the student body would grow incrementally into the space, right through to 1986, by which time the workshop would reach full operational capacity.

As soon as the kilns and machinery were in place, Moje turned his attention to the Bullseye glass. (The interviews for 1983 student intake took place in November, the remaining time not taken up with organisational matters was his own.) The new glass, resolved compatibility issues aside, was as yet an unfamiliar material. He would need to investigate its behaviour thoroughly before determining how best to use it. Moje had made only two or three pieces with it back in Hamburg, but had already identified a problem with air bubbles, which wasn't a fault in the glass per se, more a matter of personal displeasure (the Moje precision and control imperative). He soon worked out a stacking (on edge) technique that effectively expelled the bubbles, and road-tested colour combinations to his increasing delight. It was early days of course; the Bullseye 'Tested Compatible' was in its infancy and required considerable cutting skill.[25] But already Moje knew that he had found a glass he could really take possession of, a glass, moreover, offering as yet unchartered application.

23 The hot shop would finally be completed in 1986.
24 Klaus Moje, 'Thirty Years of Exploration in Glass', *Glass Art Society Journal*, 2000, page 50.
25 The early production sheets weren't very straight and cutting was consequently rather difficult.

1984 Moje with the students from the first and second intake (Neil Roberts standing at the rear).

Enders working in her studio at the old Canberra Brickworks.

In the January of 1983 Moje travelled to Adelaide to both attend and speak at the third AusGlass Conference, which provided, in addition, his first opportunity to observe Australian contemporary glass culture en masse. When asked at the members' exhibition for his estimation of the standing of contemporary Australian glass he had candidly observed that it appeared to lag 'about 10 years behind Europe and America'.[26] Having attended the conference with his habitual goodwill and an expectation of open exchange and debate, he was horrified to later discover that he'd unwittingly ruffled a flock-full of feathers. His remark, in fact, had no patronising intent. He had merely stated the obvious: the local studio-glass movement was barely 10 years established. It hadn't had the benefit of evolving from a strong industrial tradition and was predominantly representative of fractured, valiant labour carried out in near-splendid isolation. While the enthusiasm was commendable, the existing pockets of sophisticated practice were not, by any stretch of the imagination, widespread.

Moje had sent two newly finished Bullseye pieces across to Adelaide for the members' show, which effectively marked the beginning of his 'New Horizon' series (1983). Already apparent was a clear departure from the cane pieces he had made and exhibited in Germany barely seven or eight months before. The work now had a painterly sensibility, gifted to him again by the glass itself. The slight wavering inconsistencies in the thickness of the new glass – a serendipitous offshoot of the revised stacking method – lent an impression of soft, hand-painted brushwork. This, paired with the extended colour palette, would allow Moje to later progress the 'washed silk' phenomenon with complete control. From here on in he could be as tight, or indeed as loose, as he wished. In the years since, many observations have been made concerning the dramatic shift in Moje's work when he arrived in Australia (the amplified colour, the unfettered exuberance and so on), the prevailing theory being that the change was driven by a perfectly natural response to the notorious Australian 'light' and environment. While there is some truth in this (indeed, how could he not be affected, even subliminally), in actuality the sudden expressionism was more a manifestation of his sequential duet with the material. The freedom he experienced came from his realised boundlessness.

The opening of the second *National Glass Biennale* at the Wagga Wagga City Art Gallery in regional New South Wales coincided with the Adelaide conference. Between the two, Moje was treated to an instant survey of Australian glass. By the commencement of the academic year he had a solid picture of the broader state of play and a fortified commitment to the tenor of his program. The first semester at the School of Art started in March, and all first-year students – regardless of their designated workshop – entered what was known as core studies, a foundation program of intensive induction to drawing, painting and sculpture. Students didn't, as a rule, have access to the workshops proper until second year. Moje's workshop policy, from the outset, was that students would be allocated an individual working space, and he had no intention of discouraging them from frequenting the studio whenever their core commitments allowed.

The installation of Moje's own workshop within the facility was of far greater consequence than the mere convenience of fast-tracking the commencement of the program.[27] Watching him at work, as opposed to setting up staged demonstrations, effectively gave the students an immediate and authentic introduction to the machinations of professional

26 Klaus Moje, in interview with Megan Bottari.

27 It also conserved funding. For years Moje put off the removal and replacement of his own kilns and machinery so that he could stretch the funding to the further development of the rest of the studio, the hot-shop included.

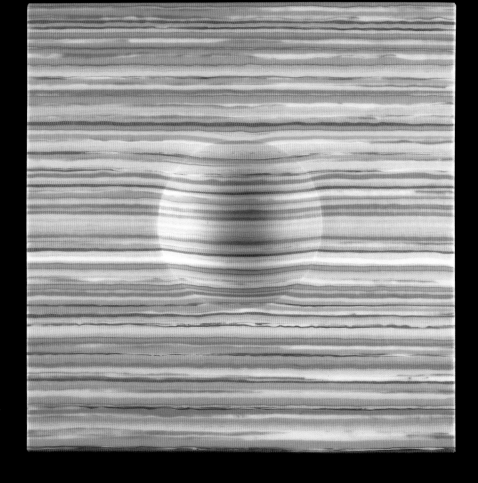

1984 **Untitled**

5 x 42 x 42cm

When I arrived at Bullseye Glass Company 23 years ago, Klaus Moje and Bullseye's large-dreaming art school graduate founders – Dan Schwoerer and then partner Boyce Lundstrom – were already on a common search for the solution to incompatibility between glasses for kilnforming. Bullseye's development, two years prior, of the world's first line of tested compatible glass had taken root from the inspiration of this remarkable German artist and the technical adventures of a naïve but tenacious young American factory. What I noticed, however, on walking into the Neverland of Bullseye in the early 1980s, was that Klaus had left a mark far greater than the birth of a new type of glass. The encounter between Klaus and Bullseye had become the archetype that would shape the company's future: research and development through artist projects.

Without Klaus, we would likely not have gone on to work with Narcissus Quagliata, Dale Chihuly, Lino Tagliapietro, Bertil Vaillen, Dante Marioni, Kirstie Rea, Scott Chaseling, Giles Bettison, Jess Loughlin, April Surgent or the legions of other inspirational artists who have pushed us to tweak our glass to fit often unorthodox demands.

Our relationship with Klaus through his early years with the Glass Workshop at the Canberra School of Art also proved to us the value of a factory's involvement with school programs. Although the first participants in our International Young Artists' residency at the factory would eventually be the students of Stephen Procter and Jane Bruce, without Klaus it just would not have happened.

Years after Klaus ceased teaching at the Canberra School of Art, in spite of the many thousands of miles that separate us and the infrequency of our actual contact, we – like so many others – continue to be shaped by his spirit, his sense of exploration and of community. His shadow continues to astound me in its reach.

One day some months ago, I was invited to join a private internet bulletin board organised by a group of emerging artists working with kiln-glass methods in the USA. Few had any personal connection to Klaus, but they were a community, sharing ideas, pushing limits with their work and aspiring to reach the heights of the medium. They sent me the secret password to log on to their site. It was 'MOJE'.

Lani McGregor
Partner (with Daniel Schwoerer)
Bullseye Glass Co, Portland, Oregon

practice. He was able to imbue the studio with a culture predicated on diligence, rigorous critique and (above all) corporate responsibility: to the craft, to the community, to the *cause*.

In the interests of the cause, he knew only too well the importance of instilling a conscious awareness of 'the big picture'. The opportunity of travel and exchange had historically been *the* decisive factor in the successful development of studio glass – and he was quite determined to introduce the practice at the school. He had already started the process of lobbying the Crafts Board of the Australia Council through its director, David Williams, for grants to provide travelling scholarships to Pilchuck. His perseverance was rewarded – he eventually succeeded in gaining funds for two annual scholarships.[28] The obvious reciprocal benefit of this, it went without saying, would be the elevated international awareness of the Canberra School of Art itself. His own participation in 'the big picture' naturally continued. He showed work in *Nippon Gendai Kogei Bijutsu* in Japan, and at the *New Glass in Germany* exhibition at the Kunstmuseum in Düsseldorf.

But the most significant event of the year was a home-front initiative. Enders, who by now had established her own workshop in one of the artist studios at the old Canberra Brickworks, was *enceinte* with twins! In happy anticipation of Amos and Danilo's arrival they promptly searched for a permanent nest and bought a house in Yarralumla. The process was not without the mandatory real-estate hitch, and for a brief period of time (between vacating the rented house and taking possession of their own) they were obliged to make the most of a bohemian existence in Enders' ceramic studio at the B rickworks.

Most of Moje's time and energy in these first couple of years in Australia was necessarily focused on the dual establishment of the school and the home-and-hearth. By the time the second year students were officially in the workshop and the new first-years in foundation, he was able to set in motion the philosophical modus operandi of the program. Regardless of his evident authority, he encouraged a climate of egalitarianism on the workshop floor, the foremost commandment being independence of thought. In fact he actively invited challenge, being a great believer in the efficacy of controversial discussion, conditional always to the spirit of mutual respect. He even incited involvement in student politics, seeing it not only as an ethical social imperative but also an effective exercise in self-assertion and advocacy.[29]

As for the curriculum itself, concept and technique were accorded equal billing and, in addition to thorough training in a wide range of skills, students were directed towards solving technical problems through daily group discussion. Consequently, because each was exploring a unique set of creative ideas, the craft skills acquired by the individual became the shared and common knowledge of the group. Moje was no champion of secrecy, trade or otherwise. The professional 'role-modelling' remained a constant in the course. He was making work that year for a number of exhibition commitments abroad: the *Triennale des Deutschen Kunsthandwerks* in Frankfurt, Germany; *Deutsche Glaskünstler*, which was also touring Germany; *World Glass Now '84* in Tokyo and Kobe, Japan; and *Nine Artists in Glass* at the Snyderman Gallery in Philadelphia, USA. During the School of Art's mid-year break, he again taught a session at Pilchuck, making good use of this rare opportunity to experiment with Bullseye in the hot-shop. He laid out mosaic tiles, which Billy Morris (as gaffer) picked up and encased in furnace glass to produce

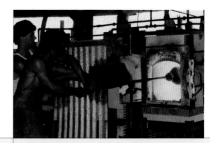

1984

28 Of the two scholarships, one was permanently allotted to
The Canberra School of Art Glass Workshop, while the other
alternated between the other Australian tertiary
glass programs.

29 Even the current Head of Workshop Richard Whiteley,
one of the second intake of students, would serve his
time as Student Union representative!

Billy Morris gaffering 'mosaic tile' vessel for Moje at Pilchuck. A gaffer is the master blower, the glass equivalent to a 'gun shearer'.

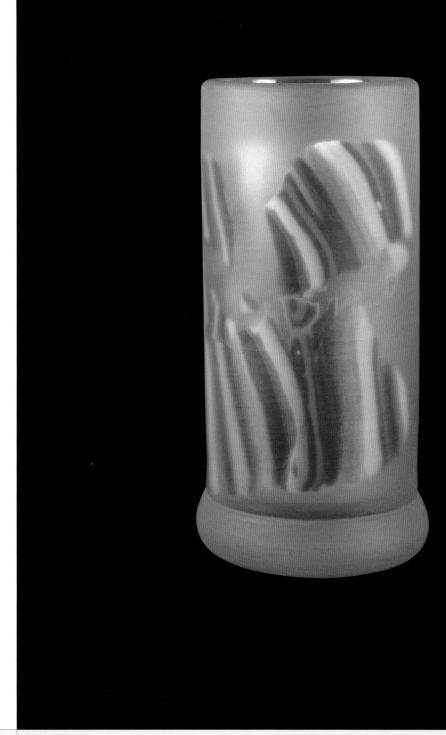

1984 | **Mosaic tile inclusion**
40 x 16cm [dia.]
(Gaffer Billy Morris)
Collection of Parliament House, Canberra

When we first met Klaus, kiln-formed glass was relatively new to us. What attracted us, among other things, was the vibrancy of the colours, the diversity and complexity of the patterns, the battutoed surfaces that made you search for the handwork and the way Klaus so ably controlled colour in the annealing process, freezing it at just the right moment so that sometimes it ran or feathered or marbled or just stayed in place rigidly, mosaic-like.

We watched his palette grow brighter as he spent more time in Australia. We were captivated by the way Australian themes infused his work. We discovered the 'Shield' series, among them an exquisite orange piece that we've given to the Los Angeles County Museum of Art. But he explored other themes too. There is the piece we affectionately call the Santa Fe piece; it's a cross (on the diagonal) that jumps out at you because it is surrounded by frosted clear glass. His opaque almost trompe l'oeil-like pieces helped us see just how painterly glass can be. Suddenly we found ourselves the proud owners of one of his earliest triptychs.

Later we saw his retrospective show and an early work that we affectionately call the tortoise because it looks just like a tortoise shell. Now it graces our family room. As much as we love the larger work, the smaller pieces are wonderful gems – Klaus masterpieces in miniature.

One other thing is clear: what distinguishes our relationship with Klaus's work is Klaus himself. He is a warm, rich, sharing, generous and thoughtful soul. We love listening to him speak. He is a passionate man who really thinks about what he says. It is a pleasure to spend time with him; his active intellect and his passion about this art form is always evident. He is a devoted and generous teacher and you can see that in the work of his many students. He has given new meaning to and invigorated kiln-formed glass.

Finally, our relationship with Klaus has also enriched our personal life. Two of Klaus's most treasured patrons have become great friends, Cynthia and Jeffrey Manocherian, whose collection of his work is outstanding.

Susan Steinhauser and Daniel Greenberg
Collectors, Los Angeles

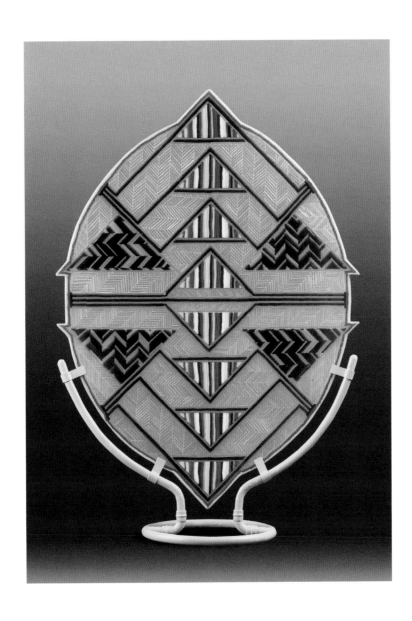

63

1985 | **Ceremonial Dance Formation**

from the 'Shield' series

5 x 59 x 45cm (not including stand)

Collection of Kunstmuseum, Düsseldorf, Germany

1985 | **Urriara Crossing**
from the 'Shield' series
5 x 59 x 45cm (not including stand)
Collection of Kunstsammlungen der Veste Coburg,
Germany

I first met glass artist Klaus Moje in the early 1980s. This was not long after he had arrived in Australia following his appointment as Senior Lecturer and foundation Head of the newly established Glass Workshop at the Canberra School of Art in 1982. I was then Director of the Crafts Board of the Australia Council and Klaus had come to see me with a simple proposition. He wanted assistance to allow two young art school students studying glass to attend the Pilchuck Glass Summer School in Seattle, USA. Knowing existing policy precluded support for students, Klaus argued that since studio glass was in its infancy in Australia, it would be strategic and in the best interests of glass development to invest travel funds in the up-and-coming generation of practitioners. The board subsequently changed its policy and for several years assisted art school students to travel to America to join the buzz of Pilchuck. Thanks to Klaus and his extensive network of contacts, many Australian glass artists have now experienced the dynamic of this famous Summer School.

Since the early 2000s, Klaus has been influential in the development of the Canberra Glassworks. It's a logical extension to his involvement in the ANU School of Art Glass Workshop which has graduated a very high proportion of Australia's high-achieving glass artists. The Glass Workshop Klaus commenced and developed has achieved international status, and now Canberra and Queanbeyan are attracting the relocation of artists aiming to capitalise on the energy, activity and abundant talent associated with the school. The Canberra Glassworks facility, scheduled to open late in 2006, represents a manifestation of the inspired work and vision Klaus developed more than two decades ago.

Klaus's influence cannot be measured in isolation. His generosity in sharing his network, arranging introductions and invitations, facilitating workshops and conferences and inspiring confidence in decision and policy makers has been significant. He has inspired talented young Australians whose techniques may be derived from his example, but their ideas, which have evolved from the history of studio glass in Australia and the individuality of the Australian visual arts in general, have taken their place on the international stage.

Klaus's central contribution to these developments has been recognised with the Award of an Honorary Officer in the General Division of the Order of Australia, AO. A mentor, inspired leader in his field and friend it has been a pleasure to work with Klaus Moje over the years.

Professor David Williams
Former Director, Canberra School of Art,
Australian National University

65

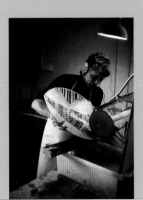

1985 Moje grinding a shield on the lathe.

very thick and heavy vessels, which Moje later battuto'd in the cold shop.[30] Later in the year, daughter Mascha arrived for a summer visit that stretched into permanency.[31] Liking the campus so much she stayed on to study gold and silver smithing with the then Head of Workshop, Ragnar Hansen.

As the Glass Workshop progressively settled into place Moje was able to increase the time spent on his own studio practice. Concurrently, of course, he was still dealing with any number of attendant organisational hassles. The establishment of the hot-shop, most particularly, was proving problematic. The Glass Workshop patently required extra space to accommodate it and the sensible solution would be expansion into the area adjoining the back of the glass facility, which at the time was being used by the Ceramic Workshop for a woodpile. He was experiencing some resistance from that quarter. Nonetheless, the revised[32] expectation of hot glass being on-line by the commencement of the 1986 academic year remained optimistic.

The big, near *cause célèbre* of the year came when Moje brought a glass fraud to the attention of the Australian National Gallery's Curator of European and American Art, Michael Lloyd. 'ANG's First Frauds?' screeched the headlines in the local press![33] The goblets in question, purchased only that year for a not inconsiderable sum, were reputably the work of German artist Karl Koepping (1848–1914). Moje who was very familiar with Koepping's work – and indeed, back in Germany, had mended a number of his pieces over the years – had serious doubts about their authenticity. The gallery, leaving the offending glass on display until such time as corroborative expert opinion could be obtained, sent transparencies of the work to the noted Koepping expert, Helmut Ricke, the then Curator of Decorative Arts at the Kunstmuseum in Düsseldorf. In due course the goblets were quietly packed away.

The next year, 1985, Moje ratcheted up his exhibition practice a cog or three. Across the Pacific he showed at Habatat Galleries in Detroit; the Kurland-Summers Gallery, Los Angeles; and in *John Kuhn – Klaus Moje – Richard Ritter* at the Glass Art Gallery in Toronto, Canada. In Europe he exhibited in *Material and Form*, Metièrs d'Art en Allemagne, Paris; the *Samlingen of Moderne Internationale Glastkunst* in Ebeltoft, Denmark; and at the second *Coburg Glass Prize* held at the Coburg Castle, Germany, at which he was awarded the prestigious Dr Maedebach Memorial Prize. Closer to home he showed at *World Glass Now '85*, at the Hokkaido Museum of Modern Art, Japan; at the third *National Glass Biennale* in Wagga Wagga, regional New South Wales; held his first Australian solo show at the Glass Artists' Gallery, Sydney; and was guest exhibitor and judge of the annual Philips Studio Glass Award in Auckland, New Zealand. The piece that won the Maedenbach prize, *Ceremonial Dance Formation* (1985), was highly characteristic of Moje's practice at the time and belonged (with another piece shown in Germany, *Urriara Crossing*,[34] 1985) to his 'Shield' series. The Shields, along with numerous 'Split Forms' made throughout the mid- to late-1980s, constitute a body of work perhaps best defined as 'dynamic construct' and mark the extremity of a relatively brief pursuit of angular formality.[35] The early test pieces of the Bullseye glass (which coincidentally also produced the softly lyrical 'New Horizon' series, 1982-83) had revealed such a capacity for control that he was compelled to impose it. Given his predilection for scrupulous investigation, it is hardly surprising that this line of exploration evolved into a continuum of hyperbolic geometric challenge. This is work that quite

30 One of these pieces is in the Parliament House collection, Canberra.

31 Mascha Moje now lives and practices jewellery in Melbourne, and teaches at Monash University.

32 There had been quite a degree of funding 'argy-bargy' and prolonged debate over technicalities pertaining to the hot-shop's furnace.

33 *The Limestone Review*, 12 July 1984.

34 Both pieces remained in Germany; *Ceremonial Dance Formation* in the Coburg Collection and the *Urriara Crossing* in the collection of the Kunstmuseum in Düsseldorf.

35 The 1980s aesthetic was dreadfully pervasive. Moje is one of the few with the mastery to survive the attendant stylistic indignities. He is disarmingly frank in interview with Megan Bottari when he sagely reflects that: 'Good or bad, we are eyewitnesses of our time.'

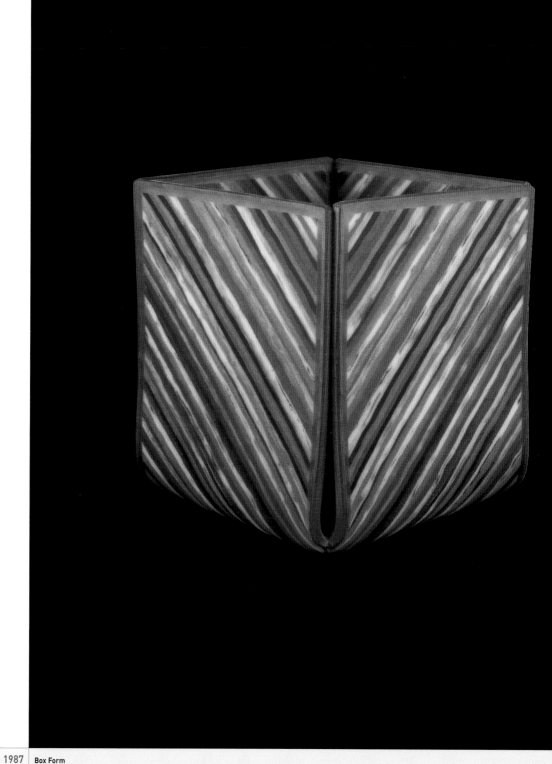

1987 **Box Form**

19 x 17 x 17cm

Collection of the Kunstmuseum, Düsseldorf, Germany

68

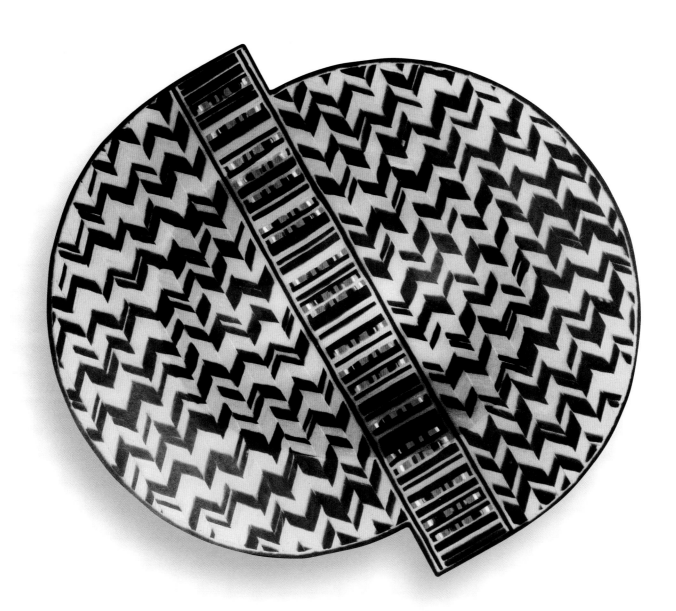

1987 **'Split Form'** series
7 x 57 x 50cm

literally protrudes with virtuosity, and while undeniably astounding (awesome, even) it is frankly a relief when, having mastered the process to his own satisfaction, he loosens up again.

Back in the Glass Workshop the saga of the hot-shop continued, though Moje had succeeded in brokering a quid pro quo arrangement with Ceramics, who gained a permanent roof over the remainder of their outdoor space. Assistance with the actual installation of the facility became an incredibly frustrating series of unreliable starts. So much so that when Scott Chaseling (a former JamFactory associate) arrived for a student interview in November – with the expectation that hot-glass would be on the program the following year – there was still serious doubt about whether the hot-shop would be operational. At the time, the furnace floor had just barely been laid before being promptly abandoned again. The question of teaching staff also needed to be revisited – Neil Roberts's studio focus had by now moved almost entirely away from blowing towards sculptural installation. Moje didn't take Chaseling on as a student – he offered him a job instead.

The year 1986 represented an important milestone in the program. At last the workshop was running on full occupancy and the year's end would mark a coming-of-age of sorts: the graduation of the original intake of degree students. Chaseling, with the help of only a mechanical drawing and the workshop technician, had the furnace, glory hole and annealer built by mid-year, after which he spent a mandatory six months giving the facility an exhaustive test-run![36] Already the philosophy of exchange and responsibility had become the axiom of workshop practice, with two of the fourth year students – Kirstie Rea and Meza Rijsdijk – taking on (in tandem with their own intensive studies) the teaching of the sub-major

component of the course. Such things made Moje very proud.

His yearly exhibition round included a solo show *Structure and Colour: Fused Glass Forms* at Heller Gallery, New York, and he was featured in both the *Saxe Collection* at the Oakland Museum, San Francisco, and a group show that travelled the USA to such venues as the Ella Sharp Museum, Grand Rapid Museum, Krasl Art Centre and the Midland Centre for the Arts. Mid-year he taught at Pilchuck. There was a reshuffle again on the real-estate front when he and Enders moved to Rivett to better accommodate two lively three-year-olds and a new studio-in-progress. They had sold their Lucie Rie and Hans Coper collection of ceramics at auction in New York, which amply afforded them a shared and spacious studio/workshop.[37]

But the gala event of the year, without doubt, was the occasion of his 50th birthday. Never one to shy away from celebratory occasions,[38] Enders threw a mammoth barbeque at the old Woolshed at Yarralumla and invited 150 of his closest friends.[39] Happy snaps of the sunlit day reveal a milling crowd of kids and dogs and smiling friends, and Moje wreathed in daisy chains. One can surely sense the benign mantle of paterfamilias settling, soft, across his square and dependable shoulders. Indeed, the homage of 'Papa' was already (courtesy of the Moje twins) enshrined in the workshop vernacular. In those early days the boys attended the School of Art creche, which was located right on the Glass Workshop's doorstep. Cries of 'Papa! Papa!' rang so familiar through the day that the term was promptly adopted, with affectionate respect, by all his students.[40]

The commencement of the 1987 academic year was memorable for the *frisson* generated by the arrival of a young, masterly glassblower Dante Marioni and his assistant Joey Des Camp, both from Seattle, USA. The Americans' month-

1988 | Group shot from the Masters Workshop (l-r back row) Stephen Skillittzi, Klaus Moje, Colin Reid, Rob Knottenbelt, Richart Whiteley, Antoine Leperlier, Kirstie Rea, Stephen Weinberg, Willi Pistor, (front row) Liz McClure, Ann Robinson, Gwen Ford and Phillipa Playford.

36 Formal hot glass instruction commenced the following year.
37 Five pieces were sold for $30,000.
38 The Moje/Enders hospitality was legendary.

39 Brigitte made a point of inviting everyone he had crossed paths with in Australia!
40 And every other child in the creche besides.

What happens to an artist and his work when he radically changes his location? When Klaus left Germany in 1982 it was quite a surprise for us, or was it? At least we understood his decision arose from his living situation at that time and we accepted it.

Then an element of suspense materialised, for him and for us. We were then unable to judge what effect he had as a teacher in Canberra. In truth this was not particularly important at that time. What we wanted to know was how his work would develop under the new conditions. Would the total change in environment, landscape, way of living be obvious in his work?

He sent entries to the second Coburg Glass Prize for Modern Glass Creation in Germany, which appeared to provide the answer. The large shields with titles such as Ceremonial Dance Formation or Urriara clearly reflected something ethnological – if not derived from Aboriginal art, at least something oceanic.

The works were fascinating and genuine Mojes, but a small question remained: was this now a new approach to his work, borne out of his new life, or was it not, after all, perhaps the reaction of a travelling artist to the lure of the strange, or the exotic?

The works that followed provided the answer. More general themes, such as order and chaos added dynamics through colour and form, and the effects of the serial once again appeared in the foreground. Perhaps an Australian can recognise something Australian in these works. We in Europe could not. Klaus proved himself as the prototype of the global individualist, whose work is determined by his person, his personality and character, and less by the country in which he lives.

The question remains how meaningful it is to seek the 'Australianness' in the glass art. Is it, in the end, seeking the artistic identity of this young country? In Europe we long for distinguishability; nothing is more boring than a global cultural sameness. The curiosity for further developments in Australia is great. For me, an inner connection of what is happening on this continent is becoming recognisable, and Klaus Moje is in the process of becoming not only a significant motivator with his work as teacher and artist, but also of becoming part of the developing Australian identity in glass art.

What more could an artist wish for?

Dr Helmut Ricke
Director of the Kunst Museum, Düsseldorf

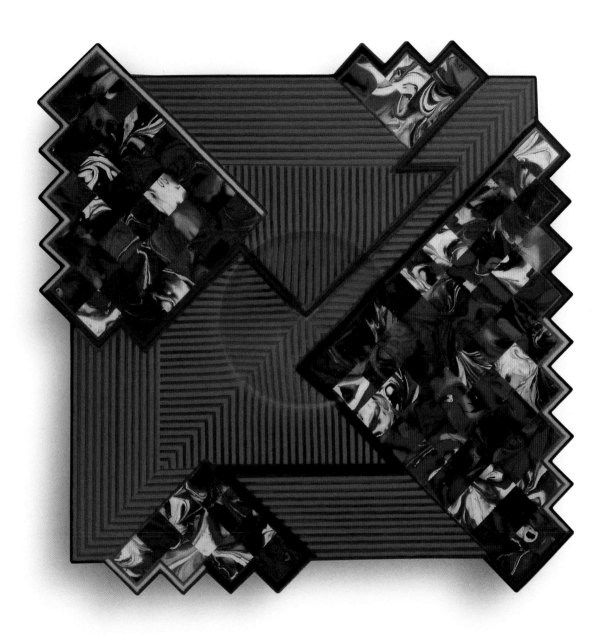

1989 **Song Lines**
5.5 x 5 x 50cm

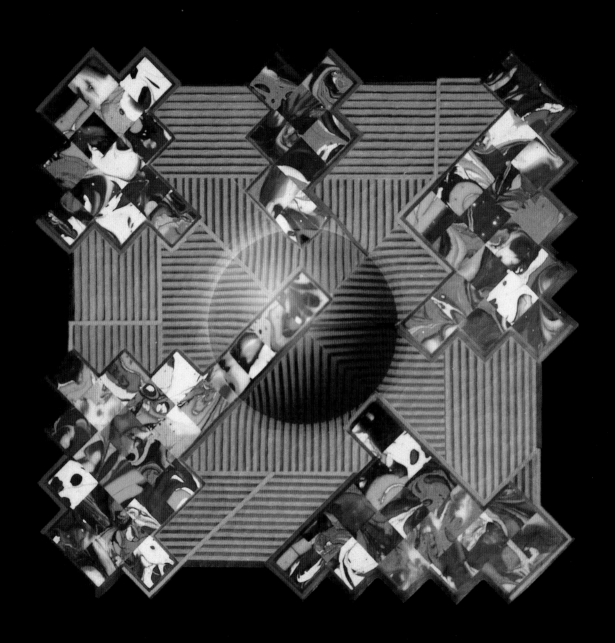

1989 **Untitled**
5.5 x 50 x 50cm

long residency heralded the introduction of what Moje viewed as perhaps the crowning initiative of the Canberra curriculum: the visiting artist program. The securing of scholarships to send students abroad had been only the opening salvo in his plans for both present and future enrichment of the course. His intent went beyond the mere fostering of inspiration. An interchange of renowned international artists, spanning the range of glassmaking techniques, would do considerably more than extend the skill-base and add depth to visual vocabulary. It was a demonstration of the very real constancy of sustained artistic practice. Every artist who visited the workshop provided living proof-positive of the viability of glass as vocation.[41] Marioni and Des Camp brought the added potency of youth,[42] and it was heady business for the students to witness such mastery and professionalism in a couple of 'dudes' of comparable age. Not surprisingly, they caused a major flurry of excitement across the entire campus.

Now that the facilities were well established and the program formally ranked and rated in the graduate stakes, Moje swung the focus even more firmly back to precisely that critical fundamental, professional practice. While the work ethic on the studio floor had been successfully propagated, it was now equally important to progress the graduates through the rigours of ongoing professional commitment. Papa wanted his brood to survive. Since his arrival in Australia he'd been shocked (and affronted on his colleagues behalf) at the price levels of the crafts. Set far too ridiculously low to sustain serious professional practice, they were clearly amateurishly costed to an uninformed market rather than calculated to acceptable wholesale standard. He refused to countenance anything less than correct and realistic costing, and he directed his students to do the same. In the early

years he had rarely exhibited in Australia partly due to the costing considerations – though it was never a matter of arrogant posturing. As a master craftsman he simply couldn't conceive of any logical reason to drop his standards. He would just quietly send the work overseas where it was always in demand and where it readily fetched its rightful worth.

The other reason for Moje's early reluctance to exhibit his work in Australia was his sense of fair play and responsibility to his students. The consummate professional, he deemed it unpardonably unsporting to compete with rank beginners, and besides, he was in the business of nurturing their development, not overshadowing or blocking it.[43] He certainly received regular and persistent requests from local galleries, but always weighed them carefully in terms of advantage to the school. At this juncture he was more interested in arranging appropriate exhibition opportunities for his graduates, and the year, in fact, had started with two graduate exhibitions, one at the Craft Council Gallery in Watson, Canberra, the other – the more publicly significant show *Form and Function* – at Melbourne's Meat Market Craft Centre during the fifth AusGlass Conference. In the latter, Moje was a proud co-exhibitor. Running in tandem he also had, as a programmed feature of the AusGlass Conference, a solo exhibition at the Devise Gallery, Melbourne. Overseas his commitments included: *New Expressions with Glass*, Hunter Museum, Chattanooga, USA; *Triennale des Deutschen Kunsthandwerkes*, Frankfurt, Germany and Helsinki, Finland; a solo show at Habatat Galleries in Florida, USA; and *Thirty Years of New Glass, 1957–1987*, Corning Museum of Glass, Corning, USA. And once again he taught a workshop at Pilchuck.

This was also the year of the experimental 'split' of the Head of Workshop position. In a plan devised to allow greater

1989 *Songlines*, a mosaic piece in construction.

41 A number of artists had stopped by briefly over the
 preceding four years, including Marvin Lipofsky and
 Richard Meitner, but until the facility was completed it
 had been impracticable to set up a workshop of any merit.

42 Both were in their very early 20s.
43 This was a path he trod with some delicacy until his
 students reached such high standards themselves that
 he was pleased to consider them fair game!

professional flexibility for staff (and a corresponding broadening of experience for the students) Sydney glassblower Brian Hirst was appointed to fill the position of Head and Senior Lecturer for the latter part of the year. Moje took the opportunity to extend his travel overseas. He already regularly surrendered teaching time and wages to enable the workshop to afford the visiting artists' residencies, and would continue to do so for the remainder of his tenure.

The 'head splitting' exercise worked in an ironic sense only and the model was abandoned, but the serendipitous upshot of it was the appointment of Elizabeth McClure to the workshop faculty. McClure had been engaged by Hirst as the visiting artist and was still on deck when, on Moje's return, Chaseling (bitten by the Marioni/Pilchuck bug) took off for the climes of the Pacific Northwest. Moje replaced him with McClure and was very glad to have her. The 1988 calendar year was heavily booked for the School of Art Glass Workshop.

The glare of the spotlight had started early, with *Glass from Canberra* enjoying the honour of being the inaugural exhibition at the new Despard Street Gallery on the waterfront at Hobart. It was a gala occasion, launched during the tall ships' visit to Hobart as part of a re-enactment of the First Fleet for Australia's bicentennial celebrations. Though he was the mainstay of the show, which featured seven of his pieces, Moje was incredibly chuffed to be exhibiting with seven of his former students[44] and clearly pleased to be perceived as the senior member and mentor of the group. 'It's the first time that Canberra appears on the map as a state [sic] where glass has been made,' he beamed.[45] It wouldn't be the last.

In April the Canberra School of Art held a Symposia of International Masterworkshops,[46] timed to precede the World Crafts Council held the following month in Sydney. In the Glass Workshop itself, Moje convened masters' classes showcasing various fusing and kiln-forming techniques in what was essentially the first event of such collective calibre ever held anywhere in the world. Of the 12 renowned artists participating there was an even international/Australian split:[47] Diane Hobson (UK), Rob Knottenbelt (Australia), Warren Langely (Australia), Antoine Leperlier (France), Willi Pistor (Germany), Kirstie Rea (Australia), Colin Reid (UK), Meza Rijsdijk (Australia), Anne Robinson (New Zealand), Stephen Skillitzi (Australia), Steven Weinberg (USA). This was a major event by anybody's reckoning and hugely influential on the Australian glass scene particularly. In concert with the workshops, *Kilnformed Glass: An International Exhibition* was on show at the Craft Council Gallery in Watson and featuring the work of the 12 participants. The School of Art Gallery presented *Over Here: Migrant Craftspeople in Australia* which was not only nicely dovetailed to coincide with the symposium, it also gave Moje (one of seven invited artists) the rare opportunity to exhibit in a show that included the ceramicist Brigitte Enders. That year he was also invited to exhibit at: *World Glass Now '88*, at the Hokkaido Museum of Modern Art, Sapporo, Japan; *European Decorative Arts*, Stuttgart, Germany; a solo at Galerie L, Hamburg, Germany; *The New Glass Aesthetics*, Habatat Galleries, Detroit; *Contemporary Art Glass*, Boca Raton Museum, Florida; and a solo show *Fused Glass Forms* at Heller Gallery, New York.

Over this time, from 1987 onwards, he continually involved himself in the promotion and advancement of studio glass on multifarious levels, both formal and informal; serving, as Exhibition Coordinator for the Crafts Council of the ACT, Canberra, and later on several committees of the Visual Arts/Craft Board of the Australia Council. In 1989 he both

44 Meza Rijsdijk, Gillian Mann, Gwen Ford, Mikaela Brown, Richard Whiteley, Kirstie Rea and Helen Aitken-Kuhnen.

45 'Limits of Glass Art Smashed', *Canberra Times*, 28 January 1988.

46 International Masterworkshops were held in textiles, glass, ceramics and silversmithing.

47 Counting Moje now as an Australian!

1989 Moje catching a star at the third Interglass Symposium at Nový Bor, Czechoslovakia.

It's been 20 years. I met Klaus Moje in 1986
when I became Head of Art Theory at Canberra
School of Art. I worked alongside him for eight
years, served with him on the Visual Arts/Craft
Board of the Australia Council in the mid-1990s,
shared a passion for Roman glass, learned a lot
about contemporary glass from him and listened,
perhaps, not enough.

Klaus was a generous colleague, a great
teacher, a wonderful leader. I nicknamed him
'Papa', teasing him about how he drove the Glass
Workshop, but mine was not the first joke –
several generations of students had already used
the name. He was tough but open; his vision was
expansive but flexible. He knew exactly what he
was doing: he was creating a field, and he
succeeded. Today Australian studio glass owes
a great part of its success to Klaus. At the time
we thought his advice about pricing was crazy,
but today I would agree that most craftspeople
undercharge. One day Robert Boynes, then
Head of Painting, joked sotto voce that Klaus
was 'foreman material' (we both knew he was
really the boss).

I discovered Klaus was fearless. In the late
1980s, when a new degree at the school called
for more art theory and history courses, he was
the only master in the craft workshops who
steadfastly backed my curriculum. He feared
neither history nor theory nor criticism. He sought
knowledge, embraced debate and wanted his
students to be the better for both. When I showed
his work at Canberra School of Art Gallery in the
early 1990s, Klaus said to place it anywhere,
that his work was good enough to stand scrutiny
wherever it was placed.

Best of all, Klaus Moje is still a colleague.
I value the precision of his opinion and his
passionate talk. My (art) world is far larger for
his presence.

Julie Ewington
Head of Australian Art
Queensland Art Gallery, Brisbane

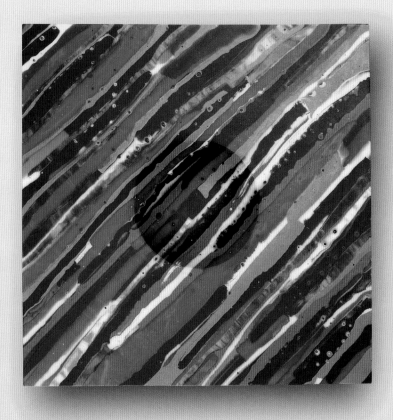

1990 | **Untitled**
4 x 44 x 44cm

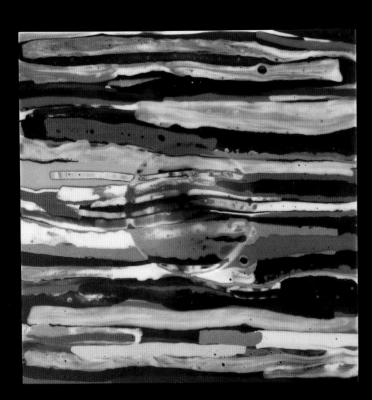

I applied for the glass program at Canberra
School of Art because I loved the material. I had
seven years of stained glass behind me when, on
a trip to the UK, I stumbled upon the 1979 New
Glass Review show at the Victoria & Albert
Museum and saw all this amazing stuff, but had
no idea how it was made. When I returned to
Canberra and discovered that the course was
starting up, I jumped at it. I initially thought I was
going to become a glassblower but (luckily!)
the furnace wasn't completed until half way into
my fourth year. By then I was very comfortably
in the kilns and cold-shop with Klaus as my
leader. I have stayed there ever since very
happily. Later when I was involved in the
'Australian Roll-up' series, I loved helping to
develop it and watch blowers (mainly Scott
Chaseling) transfer from the hot-shop to the
kilns. Very few can do that. Having known Klaus
now for over 20 years I know of his strength,
his passion and his commitment to his work.
He continues to amaze me with his boundless
energy, not only for his work but also for all he
does. I know he loves his cows as much as he
loves his glass. Klaus's support for all those
whom he sees as similarly committed is shown
through his incredible generosity and mentorship.
He encouraged his students and graduates to
go out and see what was happening in the world,
knowing that we would bring all that we learned
back here to Australia and pass it on. I feel so
privileged to have studied with, to continue a
friendship with Klaus and to call him Papa.

Kirstie Rea
Glass artist, Canberra

1990 **Untitled**
5 x 44 x 44cm

selected and coordinated the *Kiln-formed Glass from Australia* exhibition that, sponsored by the Australia Council, toured four cities across the USA.[48] His own invitations to show included *The Vessel: Studies in Form and Media* at the Craft and Folk Art Museum, Los Angeles, the first *International Crafts Triennial*, at the Art Gallery of Western Australia, Perth, and a solo show at Sanske-Zimmerman Gallery, Zurich, Switzerland. He was also a selected participant in the Third Interglass Symposium at Nový Bor, Czechoslovakia; which he attended courtesy of a grant from the Australia Council. It is little wonder that his work throughout the mid- to late-1980s should have that frenetic edge. The regimental march of herringbone, the interpose of joyous marbling, the interceding stripes, the utter sense of managed segmentation – all of this is actually an accurate reflection of his life at the time. It is an allegory, if you like, of the trials and triumphs, of the conformations and extensions, of the sheer effort involved in the building and maintenance and advancement of the Canberra Glass Workshop, not to mention the subsequent Australian kiln-forming movement. The glass, Moje's faithful confidant, records it all with sympathetic endurance.

Not much had changed by 1990: the routine of promotion, progression, and consolidation continued. Moje won the silver medal at *International Glass* at Kanazawa, Japan, and taught at Pilchuck. When he wasn't embroiled in committee work or standing at the helm of the school cold-shop (aproned in wet-weather gear, like a not-so-ancient mariner), he was focusing on two very weighty considerations. The first was his tenure as Head of the Glass Workshop, which he had self-assigned as a 10-year commitment. Though still a couple of years shy of the end date, he had already well and truly accomplished all the set objectives. The Glass Workshop

was now an influential and dominant player in Australian contemporary glass, his first generation of graduates had made their debut on the international stage and the profile of Australian kiln-formed glass was in its ascendency. For Moje the task had now reached the critical point of culmination and hereafter would be a sense of programmed repetition only. The time had come for regeneration, for a handover, and after broaching the subject with the then Director of the school, David Williams,[49] they reached an in-principle agreement to put a search in train. Not that any definitive timeline was placed on the succession; Moje himself had no intention of relinquishing the reins until they found a candidate of precisely the right timbre.

This partial resolution of the workshop responsibilities went some way towards ameliorating his other pressing concern: an exhibition with Dale Chihuly at the Ebeltoft Glass Museum, Denmark, in the upcoming year. This dual show was of enormous importance to Moje, and not least because it gave him an opportunity to celebrate a valued professional relationship with a very dear friend. It also represented serious challenge. For Moje, Chihuly was the exemplar of the American studio-glass movement, the instigator extraordinaire who'd ushered in the epoch of generous (democratic, even) virtuosity. As such it was not only an honour to be showing with him, it was essential to get it right! Moje's initial idea had been to send across pieces that were a continuation of his current work, but suddenly he found himself at the lonely terminus of the 'high construct' road. He had reached the point where there was literally nowhere else to take it. What's more, he had finally ordered and marshalled the glass so far beyond its patience that it had gone into revolt. Nothing would work for him, in his words: 'Everything I touched broke.'[50]

48 New York, Los Angeles, Fort Lauderdale and Detroit
49 David Williams was appointed director following Udo Sellbach's retirement in 1985.
50 Klaus Moje, in interview with Megan Bottari.

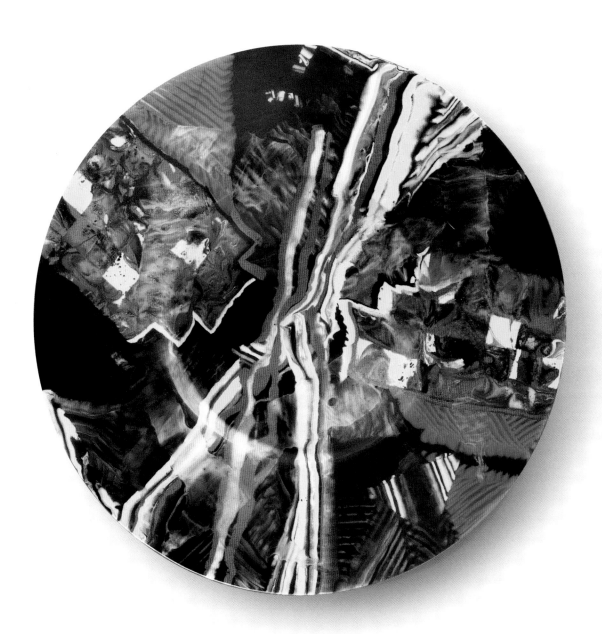

1991 **Untitled**

7 x 53 x 53cm

Collection of Simona and Jerome Chazen,

New York, USA

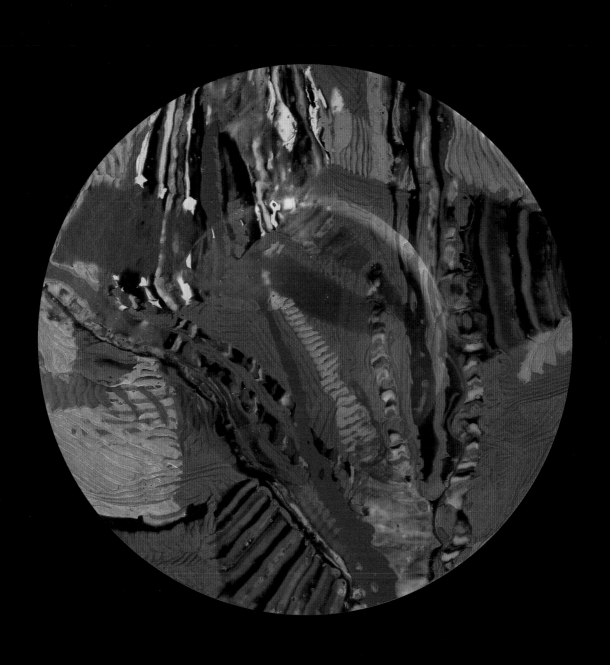

1991 **Untitled**
7 x 53 x 53cm

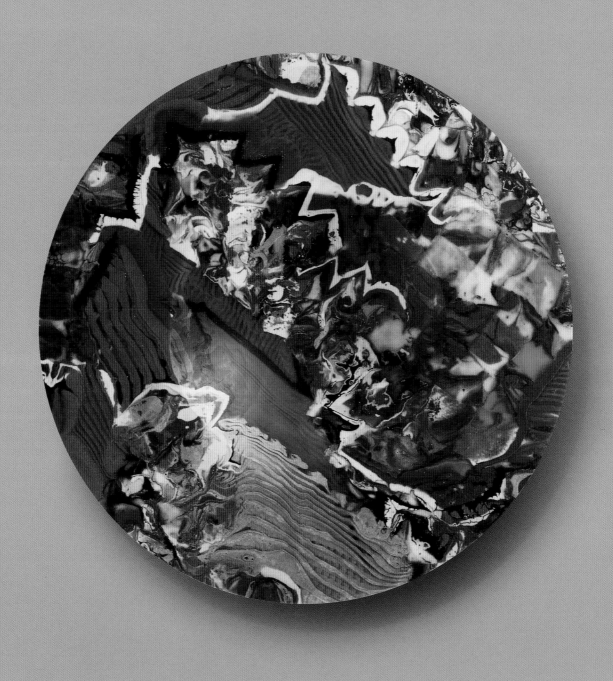

1991 **Untitled**

7 x 53 x 53cm

Collection of Henry Hillman Jnr, Portland,
Oregon, USA

It was around this time that Moje made the, quite unconnected, decision to step back from the rigours of the Head of Workshop position. While far from a *fait accompli*, the decision alone proved wonderfully cathartic. That loosening of mental stays translated directly into the work. Immediately his manic arrangements broke away and then drifted, mellow, back into the 'Floating' glass series (1990-91). He started to produce work that he'd long been thinking about, but had not had the luxury of contemplative space to make. Rims again widened into simple frames, the bowl retreated to an evocative reference, and Moje, back in touch with a pliant material, rediscovered the joys of expressive freedom.

He was back on track and afire with inspiration, and the 1991 season included invitational shows at *World Glass Now '91*, Hokkaido Museum of Modern Art, Sapporo, Japan; the *Triennale Des Norddeutschen Kunsthandwerks*, Schloss Gottorf, Schleswig, Germany; *Masters of Contemporary Glass*, Naples Museum, Naples, USA; and, of course, *Dale Chihuly – Klaus Moje*, Ebeltoft Glass Museum, Ebeltoft, Denmark. The Ebeltoft exhibition was a wonderful occasion all round, and a reunion in many respects. The founder of the museum, glass artist Finn Lynggaard, another long-time friend, perfectly summed up the general sentiments in his introduction to the show and catalogue:

> The Magicians Are Here! ... in their hands the medium is lifted out of anonymity. Not by witchcraft, but through love and hard work, curiosity and stubbornness the glass is animated with spirit and life; and through the realization of the artist's visions and dreams, we are invited to become re-acquainted with the material, and to see its rich beauty, as if we saw it for the first time.[51]

The event had turned into the unofficial launch of Moje's imminent return to full-time practice.

Moje had more than just that sense of reinvigoration of his practice to smile about. Earlier in the year he'd started the process of ringing respected colleagues to both advise of his pending 'retirement' and to sound them out for recommendations for a suitable replacement. One of the artists he contacted was Stephen Procter, in America at the time teaching at Illinois State University, whom he had first met at the 1976 *Modern Glass Made in Europe, USA and Japan* in Frankfurt all those years ago. Back then they had instantly bonded over a mimed conversation[52] and a hot cup of English tea, which Procter had served from the kitchenette of his Volkswagen Kombi, parked down on the cold, misty bank of the River Main. They had crossed paths sporadically ever since and Moje had the highest respect for this most gentle and thoughtful man, and for his quite exceptional and beautifully considered work. When he rang him for advice he never dreamt that by the end of the conversation Procter would volunteer an interest in the job himself. The search for the new Head of Workshop was over before it had barely begun. Procter was exactly the right man for the job. European master. Journeyman philosopher. Teacher. Artist. Friend.

51 Finn Lynggaard, *Dale Chihuly – Klaus Moje* exhibition catalogue, Glasmuseum, Ebeltoft, Denmark.
52 At the time Moje's English was hardly better than Procter's German.

1991 | Brothers-in-arms Chihuly, Finn Lynggaard and Moje at the exhibition opening at the Ebeltoft Museum.

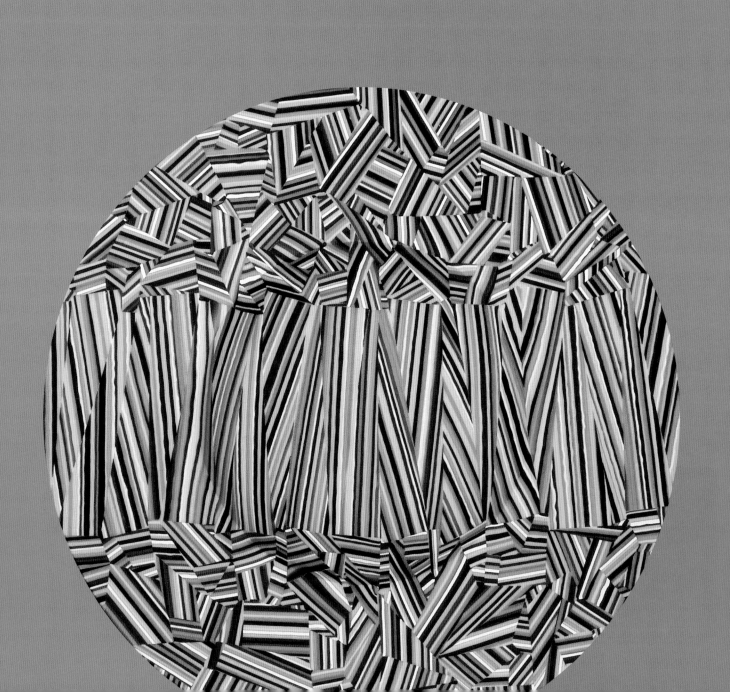

Act Three: Pastorale

Once Stephen Procter arrived to assume the post of Head of Workshop in 1992, Moje was able to effect an immediate and gracious withdrawal from the school. He would, naturally, continue a close and beneficent association, lending the weight of his considerable influence whenever occasion arose, but to all intents and purposes he became comfortably disengaged. And ostensibly unemployed! Not that he was in serious want of something to do. He had a solo show at the Nikki Gallery for Contemporary Art, Tokyo, Japan, and was invited into group exhibitions at the Ruffino Tamayo Museum, Mexico City and *Contemporary International Studio Glass*, Monterrey, Mexico; *International Contemporary Kiln-formed Glass* at Bullseye, Portland, USA; *A Decade of Studio Glass*, Morris Museum, Morristown, USA; *New Directions in Glass* at the second *Perth Triennial*, Perth; *Australian Crafts: New Works 1988–1992*, Powerhouse Museum, Sydney; and the *National Craft Award*, Melbourne.

Although he had exhibited regularly in Japan over the last several years,[53] his commitments in Australia had left Moje little time to develop the relationship further. That was about to change. While in Japan for the show at the Nikki Gallery, he accepted an invitation from fellow artist and teacher Makoto Ito to visit his studio near Mount Fuji. Having arrived there at night Moje was barely prepared for the breathtaking views and exquisite civilities he encountered in the morning light. The opportunity to work in an environment of such a unique aesthetic was totally irresistible and he was delighted to receive invitations to teach over the ensuing years. As with all his studio-glass encounters, he would find the exchange unfailingly fruitful.

The following year started with the 1993 AusGlass conference at the Canberra School of Art, which, judging by the tone of the publication that accompanied it, was nothing short of extraordinary. The roll-call of participants lists the hierarchy of Australian contemporary glass and an astonishing turnout of internationals. The Americans included Dale Chihuly, William Carlson, Richard Royal, Cappy Thomson and Stephen Paul Day; from Europe came Finn Lynggaard, David Reekie, Franz Xavier Höller and Maud Cotter; joined by Katsua Ogita and Hiroshi Yamano from Japan. The industry big wheels were John Croucher from Gaffer Glass (New Zealand) and Daniel Schwoerer and Lani McGregor from Bullseye; the triumvirate of Geoffrey Edwards (National Gallery of Victoria, Melbourne), Grace Cochrane (Powerhouse Museum, Sydney) and Robert Bell (Art Gallery of Western Australia, Perth) provided curatorial clout; and the critic's voice cut to the chase courtesy of Sue Rowley (Director of Visual Arts at the University of Wollongong) and Adelaide-based writer Dr Noris Ioannou. Every Australian glass artist worth their salt attended and are frankly just too numerous to mention.[54] Hosted by Stephen Procter and Liz McClure,[55] the conference was a fair measure of the incredibly robust constitution of the Australian contemporary glass scene. Moje attended in the capacity of (house-proud) participant.

Post-conference he left straight for Oregon to make work at Bullseye, having been invited the previous year by Dan Schwoerer during the *International Contemporary Kiln-Formed Glass* fest at Portland. Arrangements had been put in train for a three-week collaborative workshop with Dante Marioni [56] using the hot-shop of Henry Hillman Jnr, located adjacent to the Bullseye factory. For Moje it was an invaluable opportunity to further explore the compound possibilities of fused and blown vessels, an extension of the early dabbling at Pilchuck with Billy Morris and again at the Nový Bor Symposium in 1989 with the team of blowers from the Moser factory.[57]

53 At the *World Glass Now* exhibitions in Sapporo and in several others.
54 Apologies, all.
55 McClure was the incumbent President of AusGlass.

56 Whenever Moje crossed paths with Marioni since the latter's first visit to Canberra, they always had a tinker in the hot-shop, edging ever closer to Moje's as yet nebulous intent.

57 Unfortunately no examples of the work from Nový Bor have ever been seen. When Moje went to empty the lehr the following day the cupboard was bare! He took it as a compliment.

2000 | Klaus in the hot-shop at the Canberrsa School of Art.
Photographer: Achim Sperber.

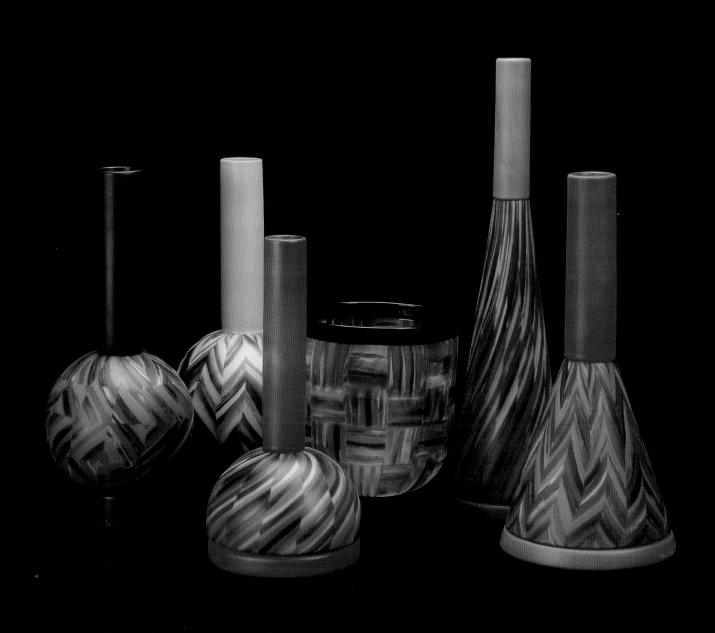

1993 From the **'M/M/P'** series
fused, kiln-formed glass, free blown
dimensions variable
(Gaffer Dante Marioni)

The 'M/M/P' (Moje/Marioni/Portland) series was a one-off. There were some annealing problems and it was a classically expensive experiment.[58] Besides, it wasn't a great seller frankly. (Moje rather suspected that the solid German aesthetic simply 'wasn't Italian enough'!) It was, however, seminal work in the true sense, proving beyond doubt the viability of the hybrid technique and flagging the embarkation of a new adventure in the annals of kiln-formed glass.

Later in the year he made a return trip to America for his solo show with Habatat at *Chicago International New Art Forms* (now *SOFA*) at Navy Pier, Chicago. By 1994 Moje was still wearing several boardroom and committee hats and showing work at *Glas-Objecte Von Kuenstlern Aus Aller Velt*, Hergiswil, Switzerland; the *International Survey of Contemporary Art Glass*, Concept Art Gallery, Pittsburgh, USA; *Pieces of Importance*, Crafts Council Gallery, Canberra; *World Glass Now '94*, Hokkaido Museum of Modern Art, Sapporo, Japan; and had a solo show at the Composition Gallery, San Francisco, USA. He also curated and coordinated the exhibition *Out of Canberra: Contemporary Kiln-formed Glass* which featured 13 artists, himself included, and toured the JamFactory in Adelaide, the High Court in Canberra and the Meat Market Craft Centre in Melbourne.

But the real business end of the year came in October when he received an Australia Council Artists Creative Fellowship, Australia's most prestigious art award. Popularly known as the 'Keatings' after the enlightened and culturally civilised Prime Minister of the day, Paul Keating, the awards (11 in all) were given 'in recognition of achievement in the arts'. Or more precisely, to further quote the official program of the proceedings:

> These awards acknowledge their [the artists] contribution to the arts and their enrichment of Australian life and, for

many, will provide the financial means to pursue excellence in their chosen field.

That provision translated into a handsome $66,000 per annum for three years and would give Moje the wherewithal not only to prepare for a planned major retrospective of his work at the National Gallery of Victoria the following year, but also (something particularly dear to his heart) to set up an extensive new studio at Wapengo on the far south coast of New South Wales.

The coastal studio had been the dream since his arrival in 1982 when, having lamented his disappointment at Canberra's distance from the sea, Allan Watt, the then Head of the Ceramics Workshop, took Moje and Enders to the rural hinterland of Tanja, where Watt himself had property, and introduced them to the National Park-fringed waters of the Sapphire Coast. The trip had ever after become a regular pilgrimage of family holidays and summers spent diving with Watt. Over the years Moje and Enders had kept a constant weather-eye out for a suitable location for adjoining studios. They found their idyll (a 50 acre block of it) at nearby Wapengo.

Moje's retrospective – always a landmark event of some magnitude in the career of the visual artist [59] – opened in 1995 at the National Gallery of Victoria, Melbourne, under the auspices of the Curator of Glass and Sculpture, Geoffrey Edwards, the authority *nonpareil* on Australian contemporary glass. Moje still vividly recalls his rush of emotion – as he walked with Enders towards the gallery along St Kilda Road – at the sight of 'Moje' banners flanking the building's iconic cascading façade. He was both humbled and thrilled, and only too conscious that the occasion also marked the 20th anniversary of the unveiling of his first mosaic form. The exhibition, *Klaus Moje: Glass/glas, a retrospective*, recorded

1993 Dante Marioni gaffering for Moje at Henry Hillman Jr's hot-shop near Bullseye.

58 Most of Moje's developmental work was expensive, though he was never one to shy away from that. The cost of the risk was the ticket to glory.

59 The retrospective with Isgard in Hamburg, 1980, though no less significant, was compartmentalised into another time and place entirely.

60 Geoffrey Edwards, *Klaus Moje: glass/glas*, National Gallery of Victoria, Melbourne, 1995. Featuring an accompanying essay from Dr Rüdiger Joppien, Museum für Kunst und Gewerbe, Hamburg.

for posterity in Edward's erudite catalogue,[60] presented a survey of the Moje oeuvre dating back to 1977.

The earliest pieces on show were carved crystal forms of seductive complexion, to which, as a characteristic mark of respect, Moje had latterly responded with a group of polygonal descendents, *Untitled* (1994); although only the soft luminescence served as a remnant hint of lineage.[61] The inclusion of several pieces from the 'M/M/P' series (1993) and the 'Box Forms', which he'd been making from the mid 1980s, underscored the continuing explorations of form: which for Moje serves solely as a conveyance for the colour and expression. In this he remained the purist – form would always follow the rational extension of his base parameters: square and circle/box and cylinder. More importantly, form would continue to function as Moje's mechanism of constraint.

The narrative of Moje's journey from the old world to the new was mapped via the palpable nuance in material, traced through the chronology of works in the exhibition. The assured elegance (pedigree, even) of the cane relinquished graciously to the energetic liberalism of the Bullseye glass. There was a moment of almost shy adolescence in the earliest of the post-arrival pieces, *New Horizons* (1982) and *My Geometric Garden* (1984): a primavera freshness that is rather sweet and curiously unsophisticated – not in the making, just the sensibility. But from there on in Moje's work evolves through his 'clever phase'[62] and beyond, to finish on a sustained high note of his now-signature luscious and uninhibited expressionism. The entire exhibition was a paean to material, Moje-style.

With assistance from the Australia Council the retrospective later travelled widely: to the Powerhouse Museum, Sydney; Canberra School of Art Gallery, Canberra; Museum für Kunst und Gewerbe, Hamburg, Germany; the American Craft Museum, New York, USA; and the Wustum Museum of Fine Arts, Racine, USA. Other shows he participated in that year included the *Hsinchu International Glass Art Festival* in Taiwan, *Canberra Contemporary Craft* at the Craft Council Gallery at Watson, and *Latitudes 2* also at Watson. This latter show was the adjunct exhibition to the first of the 'Latitudes' experimental workshops coordinated by Kirstie Rea and held at the School of Art's Glass Workshop over the next several years. An initiative of Rea's, in collaboration with Bullseye, the project was pitched to promote further exploration of the fusing/glass-blowing technique begun by Moje two years before, in Portland.[63]

Mid-year found Moje teaching a workshop at Kent State University, USA, at the invitation of the legendary glass guru Henry Halem. Subsequently, Halem added a chapter, 'The Klaus Moje Method: kiln-forming', to his fabulous DIY encyclopaedic *Glass Notes: An illustrated guide for building and maintaining a modern glass studio*.[64] Another pleasant interlude for the year was participation in *Pieces of Importance* at the Craft Council Gallery, Canberra, a show that focused on the artist as collector and invited selected practitioners to share their own favourite collectibles. Moje sent two pieces: a Chihuly and a William Morris.

Between 1995 and 1997 Moje served as a member of the Visual Arts/Craft Board of the Australia Council. In his spare time, he and Enders 'dug the first sod' at Wapengo and were setting up the infrastructure on the land, putting in the utilities and building the first large shed that would initially house the kilns until its eventual dedication as grinding shed. In the midst of all this he was maintaining standby mode for a large public artwork[65] that had been commissioned by the architectural firm of Mitchell/Giurgola & Thorp[66] through

61 Moje makes a habit of revisiting earlier themes, rather like picking up a conversation with an old friend, or adding another stanza to a favourite tune.

62 The mid-late 1980s 'dynamic construct' work.

63 The name 'Latitudes' alluded to the Canberra-Portland trans-Pacific connection.

64 *Glass Notes: a reference for the glass artist*, Henry Halem, published by Frank Mills Press, Kent, Ohio, 1996. For a reduced version go to www.glassnotes.com

1996 Family photograph taken (on the occasion of Moje's 60th birthday) during the trip to Hamburg for the retrospective exhibition at the Museum für Kunst und Gewerbe. (l-r) Brigitte, Amos, Danilo, Feline, Klaus, Ute and Jonas. Photographer: Achim Sperber.

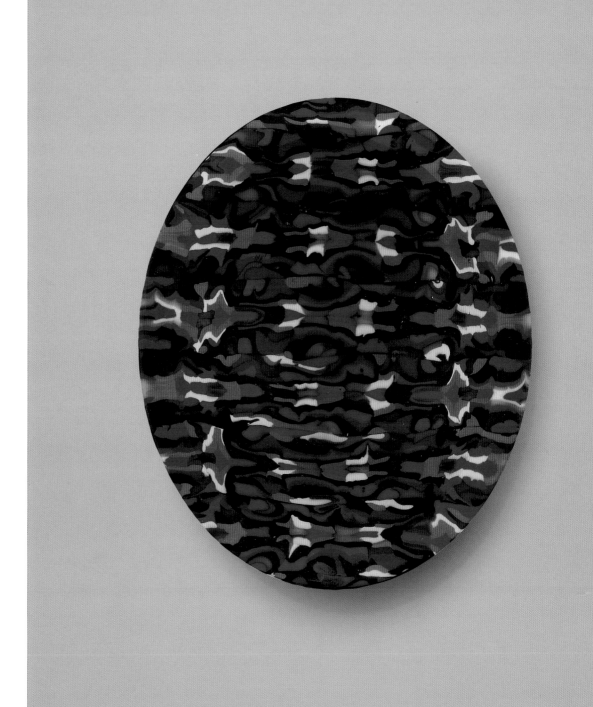

65 The commission had first been broached
some four years previously.
66 The architectural firm also responsible for
Parliament House, Canberra.

1994 | **Untitled**

4 x 16.5 x 14cm

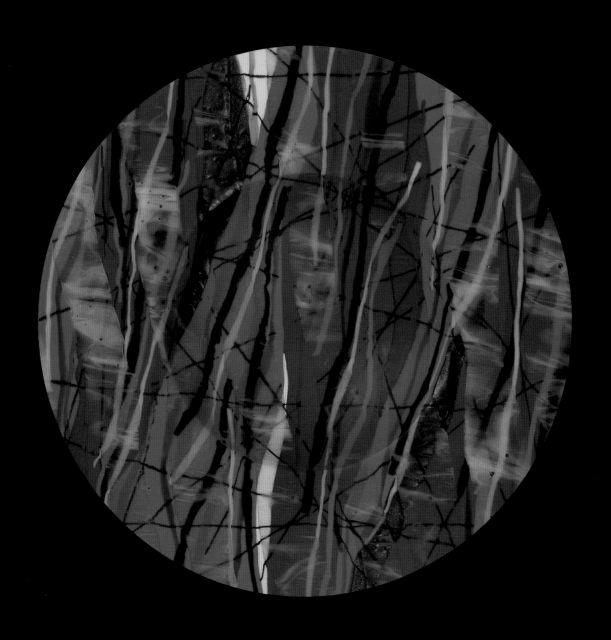

1995 **Untitled**
7 x 53 x 53cm
Collection of National Gallery of Victoria, Melbourne

Given that the collective achievement of the Australian glass movement is due to the efforts over many years of a fairly close-knit community of practitioners, institutions and others, it is a risky business to single out for special praise the contribution of any one individual from a field of many.

Nonetheless, I shall venture to recognise one unusually distinguished achievement within the Australian glass movement – one that spans the spheres of making, teaching, advocating and creating a remarkable vision for glass education and professional practice – that has been hugely influential in shaping our perception of the movement today. It is, of course, Klaus Moje's name that springs to mind in this respect. Generous, gregarious, persuasive, passionate, energetic and inspirational, Moje has been an effective champion for contemporary Australian glass and for Australian glass artists, and thus he is a natural subject for this 'Living Treasures' series of exhibitions and monographs.

Klaus's career began in his native Germany and flourished in Australia. The story of his evolving style and the changing focus of his practice – from the flickering mosaic fields of the early years to the serene minimalism of the more recent wall-mounted imagery – is a story traced elsewhere in this publication.

Thus, I will confine my short tribute to Klaus by recalling a passage from a medieval letter quoted in a museum handbook by the 19th century glass historian, Alexander Nesbitt. Written in the 8th century, this missive was sent to the then Bishop of Mainz by an English cleric, namely Cuthbert, Abbot of Wearmouth. As Nesbitt recounts, Cuthbert's letter was an appeal to his German correspondent for word of 'any man in your diocese who can make vessels of glass well'. Cuthbert goes on to say that should a suitable paragon of glassmaking expertise be found in Germany, 'pray send him to me ... for we are ignorant and helpless in that art ... (and) if it should happen that any one of the glass makers through your diligence is permitted to come to us, I will, while my life lasts, entertain him with benign kindness.'

When Klaus Moje was first coaxed to Australia as founding Head of the Glass Workshop at the Canberra School of Art, it was plainly not the case that Australia was 'ignorant and helpless' in the production of artistic glass, or at least not in the sense of which our brother Cuthbert speaks. However, in consideration of what Klaus Moje has achieved since his arrival here in 1982, as practitioner, teacher and tireless advocate for the Australian glass movement, well may we feel a serious obligation to 'entertain him' for the excellence of his efforts on our behalf, and that we do so in a spirit that is nothing short of 'benign kindness'.

Geoffrey Edwards
Director of the Geelong Gallery, Victoria

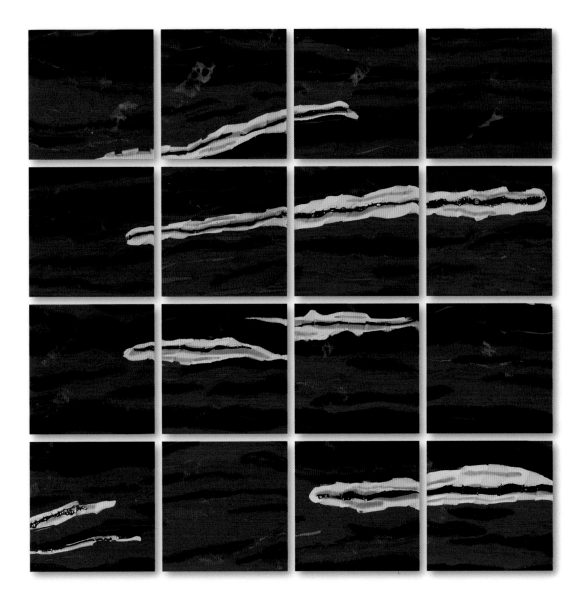

1996 **Aperto** (wall-piece)
200 x 200cm

Partner Pamille Berg. The commission was for a large wall-piece, his first such undertaking, to hang in the foyer of the refurbished ACT Legislative House of Assembly. Already the process of paperchase had been an endurance test of endlessly tangled bureaucratic dickering and disjunction, leaving the signing of the commission in perpetual abeyance. Moje had been obliged to leave it simmering on the backburner until such time as the politicians finally passed their motions.

In 1996 Moje was awarded Honourary Life Membership of the Arbeitgemeinschaft des Kunsthandwerks, in Hamburg, Germany, though ironically at this juncture he was showing less in Europe, where the deflated economics of the period were impacting somewhat negatively on the art market. He did, nonetheless, have a couple of European commitments that year: a solo at Galerie L, Hamburg, and a flatteringly prestigious invitation to show at the Palazzo Ducale during the *Venezia Aperto Vetro*, Venice, Italy. The Venetian show turned out to be an unexpected godsend. The ambient sense of occasion and the grandiose setting of the Palazzo quite literally demanded work that corresponded with appropriate scale and gesture, and the wall installation that he had been mentally nurturing for so long was an obvious solution for the space. Also, from a purely professional and practical point of view, it provided him the perfect opportunity to test run the Legislative Assembly piece.

The leap from plinth to wall had long been an inevitable, even logical, extension of his practice, but he was only too aware of the consequence (and responsibility) inherent in such a potentially provocative move. The 'painterly' descriptive was already liberally applied to his work, and a move to the wall would place him unequivocally in a position of trespassing into the realm of the painter. He wasn't shy of the challenge but had no intention of testing the water until he'd established, to his own satisfaction, that he could technically *and* artistically do so with faultless aplomb.[67] Helmut Ricke in his essay 'On Order and Chaos' written for the 1991 *Moje/Chihuly* exhibition at Ebeltoft, had speculated:

> You can discuss Moje's work in the same terms as when you talk about paintings. And as a matter of a fact they often present themselves as monumental, wall bound images. They could be enlarged to any dimension, and it is tempting to imagine an exhibition where pictures, perhaps large-scale photos, complimented and added dimensions to the actual object.[68]

Ricke was right except in one respect: Moje would never be content with a mere photograph of his work. The time had come, he decided. He and the glass were finally ready to strap up and enter the arena.

The Venetian piece was a great success and travelled afterwards to exhibitions in Denmark and Sweden before reaching its final destination in America at Bullseye. Lani McGregor and Dan Schwoerer acquired it for their own collection – they needed something to counterbalance an imposing *Red Reed* sculpture of Chihuly's. The large and equally imposing Moje wall-piece was the only work that could hold its own in the same room. In interview with *American Craft* magazine, McGregor commented: 'Displayed together, the Chihuly and Moje works are a summit meeting between the leading masters, respectively, of blown and fused glass … We wanted something that would dwarf a Chihuly. All the glory goes to the blowers … it's hard to be a country cousin.'[69]

Irrespective of the dampened European economy, Moje certainly wasn't left running idle. He still had more than enough work to do for his American galleries: a solo at the 93

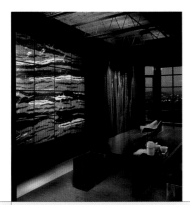

1996 The *Aperto* wall-piece, at home in Portland with the Chihuly *Reeds*. Image courtsey of Bullseye Glass Company.

67 That imperative for crafted perfection again. Moje *never* puts anything 'out there' until he has fully mastered it.

68 Helmut Ricke, essay 'On order and chaos: notes on the work of Klaus Moje', *Moje/Chihuly* catalogue, edited by Finn Lynggaard, published by Glasmuseum, Ebeltoft, Denmark.

69 'Material Matters, at home with Dan Schwoerer and Lani McGregor', interview by Randy Cragg, *American Craft*, June/July 2003

Seattle Art Fair, Seattle (where he was represented by Ruth Summers Gallery), and Habatat featured a Klaus Moje/Pavel Hlava show to celebrate its 25th anniversary exhibition in Florida. Of the work shown at Habatat, *Fused Glass Panel #11* (1996), gave just a wee glimpse of things to come later in the year at Niijima. He also showed in *Art in Glass '96*, at Editions Galleries in Melbourne, and travelled to Japan with a delegation from the Visual Arts/Craft Board of the Australia Council.

In 1997 Moje found himself with innumerable exhibition commitments: *International Contemporary Glass*, Hsinchu Cultural Centre, Taiwan; *From Venice to Ebeltoft*, Ebeltoft Glasmuseum, Ebeltoft, Denmark; Museo del Vidrio, Monterrey, Mexico; *Australian Glass*, Galerie Rob Van Den Doel, Netherlands; and *Via Venedig Til Varberg*, Varberg, Sweden. In New York he received the prestigious UrbanGlass Award for innovation in glass technique and was invited onto UrbanGlass's International Advisory Committee. Back on the home front he was a member of the advisory committee for the Parliament House Art Collection, Canberra (1997–99), and he had finally been given the green light for the wall-panel for the Legislative Assembly.[70] He had shown in *Drawing on the Diaphanous* at Michael Nagy Fine Art, Sydney, and held a solo show, *Klaus Moje: Recent Work*, at the Craft Council Gallery in Canberra. At the Craft Council show, he included the first wall-piece seen locally,[71] in response to which Neil Roberts had cheekily exclaimed: 'Hey, Jackson Pollock in glass!'[72] Towards the end of the year the founder and Director of the Niijima Glass Centre, Osamo Noda, invited Moje to Japan to be master-in-residence[73] at the 10th Niijima International Glass Art Festival. Little did he expect when first accepting the invitation that this would be the pivotal juncture in the resolution of his hybrid kiln-fused/blown technique.

On arrival he had been suddenly confronted with a request to conduct a hot-shop session – something that he'd come completely unprepared for. Wracking his brain for a quick solution he lit on the idea of responding to the Edo period textiles that had enthralled him during the previous day's stopover in Tokyo. Accordingly he fused heavy glass plates, which he then sliced, butter-flied, and re-fused again. The resultant panel was later rolled-up in the hot-shop by the sessional gaffer Brian Pike, making the first of what Moje tentatively called the 'rolled hot-worked fused forms'. These tall, colourful and highly decorative cylindrical vessels would emerge into the series later known as the 'Niijimas'. Unfortunately none of the pieces from the session actually survived intact – annealing problems cracked the lot – but he took them home with him nonetheless, knowing intuitively that he had the beginnings of something really important.

He returned to Australia relatively pleased overall with the Niijima outcome, though regretful that there had not been more time to keep it on a roll – if only to iron out the annealing issues. It was a regret that he later voiced to Scott Chaseling and Kirstie Rea while showing them the slides of the 'almost made' (the glass equivalent of the one that got away). After lengthy discussion and close examination of the cracked vessel he'd also brought along, both announced: 'Hey, we can do this.' Such music to his ears! Though this hadn't been Moje's expectation, it was precisely what he wanted to hear, and they immediately put a team together and went to work perfecting the technique. By the time of the mid-year Glass Art Society (GAS) Conference in Seto, Japan, the 'Great Australian Roll-up', as it soon became known, was ready to strut its stuff – with lectures and demonstrations a feature of the official program.

70 The work was fired down at Wapengo and ground in the studio at Rivett, while the building works at Wapengo were still underway.

71 The Legislative Assembly panel wasn't actually unveiled until the following year.

72 Klaus Moje in interview with the Megan Bottari.

73 Along with Dale Chihuly.

1997 Jenny Deves at the Crafts Council Gallery, Watson.

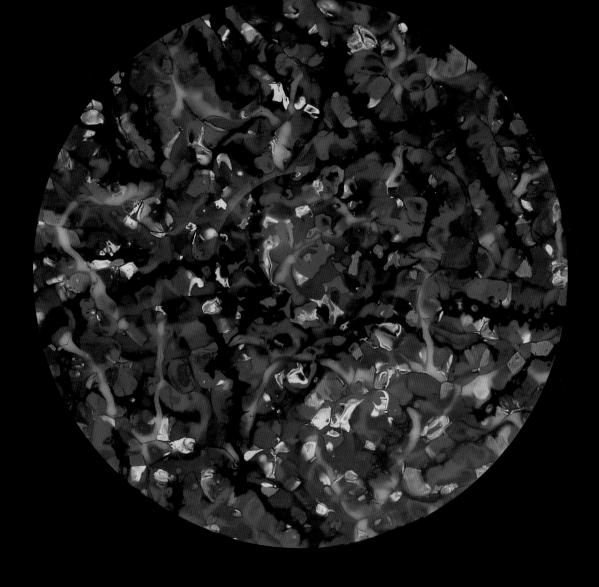

1997 | Petals
4.5 x 47 x 47cm

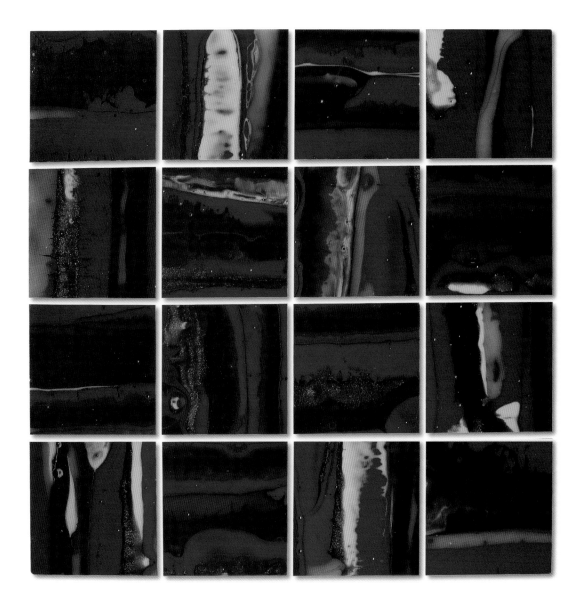

1998 **ACT Legislative Assembly** (wall-piece)
200 x 200cm

In the meantime, the ACT Legislative Assembly piece had finally been officially hung, which Moje commemorated as being 'a true symbol of multicultural expression'.[74] Colour, he explained, was the common language of all people, and inasmuch as the House of Assembly represented the people of the Australian National Territory, so too did the predominant red of the piece connote the universal representation of authority, law and order. Shortly afterward he was made a Visiting Fellow at the Australian National University, a member of the Management Committee of the Crafts Council of the ACT, and later in the year was the proud recipient of 'The *Canberra Times* Artist of the Year' award. In between he had that ongoing round of exhibiting commitments: *Glass from Australia*, Gallery Enomoto, Osaka, Japan; *Essentially Canberra*, at the 1998 *Venezia Aperto Vetro*, Venice, Italy; *Masters of Australian Glass*, Quadrivium Gallery, Sydney; and a solo at Axia Modern Art, Melbourne.

Moje was given a gentle introduction to 1999, starting with the brief sedentary pleasure of judging the Presiding Officers' Craft Prize at Parliament House. It was a momentary respite from what would turn into a year bursting with engagements. *Latitudes*, the exhibition that marked the culmination of the experimental workshops of the same name, opened at the Canberra School of Art Gallery on the second leg of its travelling itinerary, with the final destination being Bullseye, Portland.[75] The 'Niijimas' were exhibited in the Canberra Theatre foyer, giving the Canberra community a peek preview of the new work just prior to its departure for the series' planned May debut at *SOFA-New York* (represented by Heller Gallery), and he also exhibited other work, including a wall-piece, in a group show *Passion* at Quadrivium Gallery in Sydney.

After that things started to heat up. First came the Bavarian State Award, presented at the *Meister der Moderne* exhibition in Munich, Germany. Then the notification that he was the recipient of the 1999 Rakow Commission – a US$10,000 award to create new work for the Corning Museum's 20th century glass collection. Finally the Glass Art Society announced that he was to receive the Lifetime Achievement Award at the following year's conference in New York. Serious accolades all, particularly the latter. Moje would be the award's 12th recipient, and the first kiln-former in its history. But that would be next year's news. For now he still had work to do for exhibitions at *SOFA-Chicago* (where he was represented by Habatat Galleries), *Contemporary Australian Craft* at the Hokkaido Museum of Modern Art, Sapporo, Japan (which later travelled to the Museum of Modern Art, Shiga, Japan, and the Powerhouse Museum, Sydney), and the *Cheongju International Craft Biennale*, Cheongju, South Korea.

His one disappointment was that, having been instrumental in the securing of the *Chihuly: Masterworks in Glass* exhibition for the National Gallery of Australia, he was then unable to spend any time with his old friend, who was flying into Australia briefly for the opening. They just missed each other at the airport. Moje was off again to Portland, with Chaseling and Rea, for the next round of roll-up demonstrations and workshops at Bullseye.

The 'Niijimas', it seemed, had spawned an adjunct industry all their own: performance art, Australian-style. For Chaseling and Rea, the technique had practically turned into a wonderful travelling circus act, one that was in increasingly high demand. They would find themselves spending the next couple of years touring the world giving demonstrations.[76] In early 2000 'The Great Australian Roll-up: a touring workshop' had moved on from the opening gig at Portland (late 1999) to workshops at

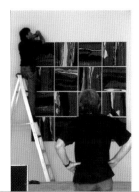

1998 Moje supervising the installation of the ACT Legislative Assembly wall-piece.

74 Klaus Moje, in interview with Megan Bottari.

75 The exhibition, not to be confused with the quite separate 1995 *Latitudes 2* show, had first opened in Seto, Japan, in conjunction with the Glass Art Society Conference. The roll-ups made for this exhibition were gaffered by Ben Edols.

76 In collaboration with Bullseye.

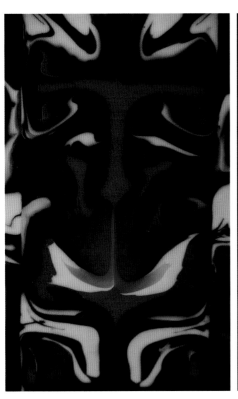 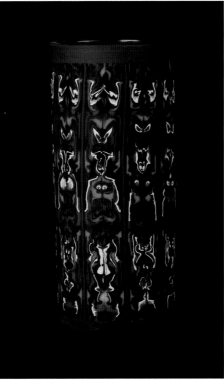

1998 **Untitled**
from the 'Niijima' series
fused and kiln-formed glass, rolled-up and blown
44 x 17cm (dia.)
(Gaffer Scott Chaseling)

If I was to say it is Klaus Moje's glass works that I admire the most about the man, then I would be wrong. Klaus Moje is a person of wisdom. I know that sounds like rhetorical admiration, though I have a belief that wisdom can only surface through when a person shows great generosity. It was this characteristic gift that first took my attention. The way Klaus gave his time, knowledge and skills to his students was, for me, unseen before.

In 1986 when I came to the Canberra School of Art for an interview to study there, I sat down with Klaus in his office and he took the jump by asking me to teach in the glass workshop. This belief and trust in people, the ability to give opportunities and to promote those around him is what I have come to realise is the foundation of teaching. Klaus never was the 'academic' teacher, a player of educational games, of today's corporate universities. He was more the skilled master giving all he had learnt along his way as a journeyman to his pupils. It was a lesson about giving, not holding back on techniques and not being a self-protective teacher fearful of the student taking any recognition.

Klaus did teach for ten years at the Canberra School of Art and has taught workshops since then, though it is more than just teaching. When there is this amount of personal resource available and the giving to promote the pupil it is more a non academic mentor. This is apparent as after all these years I still feel I am in this mentorship with him!

Over the last 20 years I have been very fortunate to have been taught by Klaus and to have taught alongside him. And yet it is the Christmases and New Year celebrations shared with Klaus and Brigitte, when he was my surrogate father at my wedding, the nights staying up late playing dice (which he still 'miraculously' manages to win) or in the studio chatting about the 'world' that is what I shall always hold close and look forward to many more times like these.

Scott Chaseling
Glass artist

99

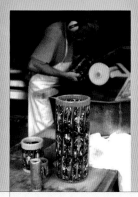

1998 Moje at the lathe with a 'Niijima' piece.

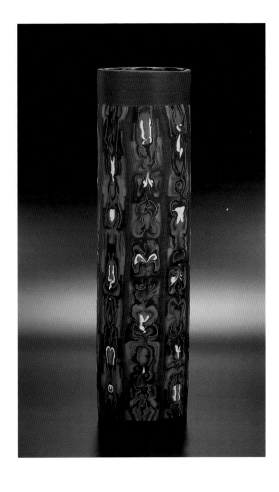

1999 **The Rakow Commission**
57 x 14cm (dia.)
Collection of Corning Museum of Glass,
New York, USA

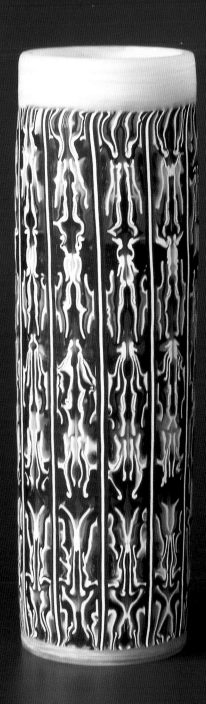

1999 **Untitled**
(from the 'Niijima' series)
52 x 13cm (dia.)

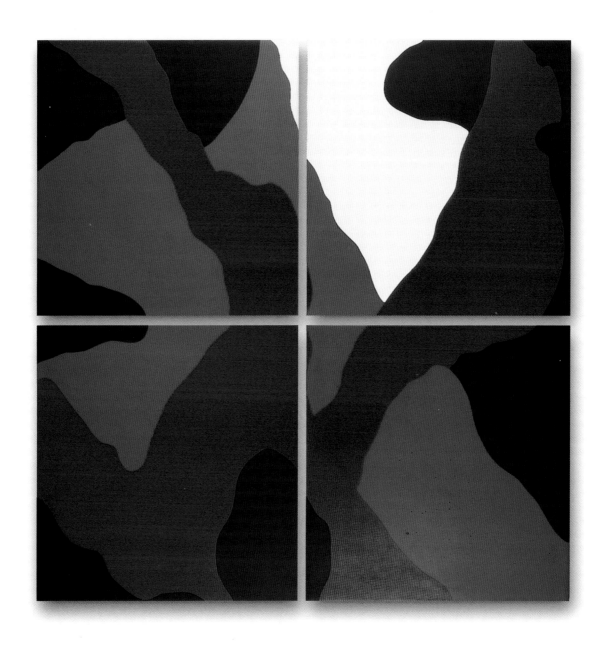

2000 **Floating Red** (wall-piece)
150 x 150cm

I am indeed flattered to be asked to write a piece about my friend, Klaus Moje. It is disappointing to me that he lives so far away as I always enjoy his company, humour, and friendship and do not see him often enough.

Klaus is, to my way of thinking, a rare artist working with a material that few have been able to master with the distinctiveness and personal vision as he has done. His work has less to do with the preciousness of the material than with the colourful expressiveness of his bright, highly charged colour field surfaces. I can best describe his creative technique and process as disarmingly simple to learn and master but one that takes a lifetime to control. His works are more of the painter's craft than the glass maker's: simple in format but complex in their colourful relationships. Many of his pieces blend the simplicity of a framed bowl into a simple, colourful object, which is the essence of a decorative container, form and colour blending into a perfect unity. At other times the works seem to be pure painting.

I am fortunate to have seen exhibitions of his work over the years and have never been disappointed in his growth as an artist. Unlike many other artists working with glass, Klaus's work has matured and grown as the years progress. His arrangements of colour and form are sometimes studied and meticulous and other times seemingly chaotic, but regardless of what hat he wears the work sings with his vision of colour, line, form and surface.

In 1995 I invited Klaus to come teach his process to my students and without hesitation he agreed. His ability to communicate and share his 'secrets' made for a very exciting class. I have fond memories of the two weeks that Klaus spent with us. Klaus is not only a friend and consummate artist but also a great teacher. The honour received from this publication is well earned and deserved.

Henry Halem
Professor Emeritus Kent State University,
Ohio, USA

Klaus Moje's vision for a teaching glass workshop was unique and comprehensive. In 1982 Klaus realised a new glass education program in Canberra that is focused on the development and articulation of the individual's voice, while laying a foundation for skills across a wide range of techniques to support an intelligent investigation of the material.

This teaching program and its approach is still relevant some quarter of a century later. Looking back, I am amazed at just how many artists have emerged from the program and how the Glass Workshop continues to generate high calibre artists. Many of these graduates find themselves with strong professional standing with only undergraduate degrees.

It is often the case that the vision and drive for such a program passes with the retirement of a catalyst, like Klaus. However some 15 years after Moje's retirement as Head of Workshop, the spirit of the program remains and has been added to by the students and staff who continue to redefine and grow the Glass Workshop. This momentum is as much a testament to Klaus as it is to those that followed, particularly the late Stephen Proctor and Jane Bruce. Today the program also draws its energy from the community of artists who have experienced this program. These artists comprise former students and staff, including Klaus, who have been touched by the workshop and who continue to feed back to it with the same level of passion that Klaus first brought to the school.

Richard Whiteley
Current Head of the ANU School of Art
Glass Workshop, Canberra

103

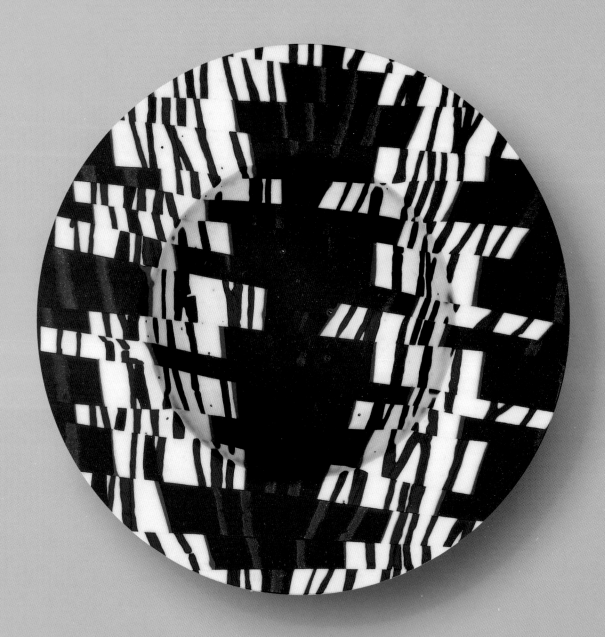

2001 Untitled
 7.5 x 49 x 49cm

the Corning Museum Studios and UrbanGlass in New York. Just in time to catch up again with Moje for a Niijima demonstration at the GAS Conference and to join him for the presentation of his Lifetime Achievement Award.

For Moje this was an occasion that had significance over and above any personal honour. It was a quintessential moment of ascendency for all kiln-formed glass. Once, long ago, in the very early days of his association with the American glass establishment, his work had been patronisingly referred to as 'niche'. Consequently, he viewed this award as part vindication of his life's work and part official declaration that the 'niche pastiche' had come in from the cold. In a culture where the hot-shop still undoubtedly reigned supreme, kiln-forming had at last been formally accepted as mainstream and accorded its due respect. Adding further dimension to the satisfaction was the fact that the award was to be presented by GAS board member Richard Whiteley – not only a kiln-forming Australian but also one of Moje's original students (second intake) from the Canberra School of Art. It would be fair to say that Moje, the artist/educator/innovator, was rather pleased.

Following the conference a veritable mob of Australians headed off to Pilchuck, in what must have seemed like an invasion of antipodean Visigoths, for a session that had been labelled with the tag 'Full Bull'. It had been given over entirely to Bullseye glass workshops – even the hot-shop had Bullseye in the furnace. Moje attended as artist-in-residence, Chaseling and Rea were giving a roll-up class, Ben Edols was teaching in the hot-shop with Lino Tagliapietro his gracious guest artist, and the Australian accent was spread across the teaching assistant and student body thicker than vegemite. From Papa's perspective the signs augured well for the new millennium.

Back at the coal-face his exhibition program was standard fare: a solo at *SOFA-New York* (presented by the Bullseye Gallery); *Defining Craft* at the American Craft Museum, New York; *Colonial to Contemporary: a Decade of Collecting Australian Decorative Arts and Design* at the Powerhouse Museum, Sydney; *Contemporary Craft* also at the Powerhouse Museum, Sydney; *Shattering Perceptions*, Dennos Museum Centre, Transverse City, USA; and the Museo Del Vidreo, Monterrey, Mexico; *Strength to Strength*, Craft ACT Gallery,[77] Canberra; and *On the Edge: Australian Glass* at Galerie Handwerk, Munich, Germany. This last exhibition featured a bevy of Australian glass artists, 26 in all, and was shown in conjunction with the Australian Glass Symposium at the Academie in Munich at which Moje both lectured and conducted a workshop (the roll-up caravan was also in town), followed by a further lecture at Zwiesel Glasfachschule. *On the Edge*, which had originally shown at the City Art Gallery in Brisbane, was later taken to the National Glass Centre in Sunderland, UK, before its eventual return to Australia to Object Gallery in Sydney.

Somehow during this year Moje and Enders also managed to complete the move into Wapengo, the combined house/studio having finally been completed. Up until this time, with the various facilities under progressive construction, Moje necessarily had to juggle his practice logistically between both Rivett and Wapengo. Commuting between processes hadn't been ideal,[78] but it had been do-able (just). Whilst they would still retain Rivett as an adjunct 'town' studio, from here on in at least Moje would be able to complete work at the one location.

105

Team Australia at the 'Full Bull' session at Pilchuck.

Moje, Daniel Schwoerer and Lani McGregor
brain-storming at at Pilchuck 'Full Bull'.

77 Formerly the Craft Council Gallery.
78 It was a three hour drive between Canberra and the coast.

The year 2001 marked both the 75th anniversary of the *Canberra Times*, the city's principal newspaper, and Australia's centenary of Federation. The relevance of the former merely being that Moje was selected as one of the 'Faces of Canberra' for the paper's 75th anniversary supplement. The relevance of the latter, however, was far more titillating. One of the programmed public art events in the national celebration was the planting of a 'peoplescape' on the lawns of Parliament House. It comprised of thousands of life-size cut out figures of 'heroes' that individuals or groups from across Australia had been encouraged to nominate (and hand-decorate). Scott Chaseling painted the 'Moje' figure in the gestural manner of Moje's latest wall-piece, leaving, as per the organiser's instructions, the other side blank to be decorated by the next (totally unconnected) group. On the day of the official opening, Moje was incredibly charmed to discover that his back-side was Kylie Minogue.

At a rather more serious gathering, not long afterwards, Moje was presented with the Australia Council's highest accolade, the Emeritus Award. The award, aimed at 'drawing public attention to the outstanding achievements of an eminent living visual artist or craft practitioner',[79] was valued at a tidy $40,000. Well-earned one would suggest, given that Moje had spent the earlier part of the year preparing a large body of work for the mega-exhibition *Klaus Moje Art Glass*, held mid-year at the Hsinchu Municipal Glass Museum, Taiwan. The exhibition catalogue reveals something akin to an 'über-retrospective'– an incredibly comprehensive survey of his life's work from wall-panels, to mosaics, to roll-ups and Nijiimas, along with the additional context of the earlier (pre-Australian) works. Some 56 pieces were included in all, with lectures and demonstrations to round out the show. He presented a

lecture at the Grand Cristall Museum, Taipei, Taiwan, followed by a lecture and workshop at Nagoya University of the Arts, Japan, on the way home. Quite separately he showed in *International Glass*, Shanghai Museum of Fine Arts, Shanghai, and the Millennium Museum, Beijing, China; *Exempla* and *The Colour Red* in Munich, Germany; *Milano meets Canberra*, Galleria Scaletta di Vetro, Milan, Italy; and a solo with Habatat at *SOFA-Chicago*.

It happened in 2001 that shadow fell across the Canberra glass community, following the illness and untimely death of Stephen Procter. Stephen would be sorely missed. An exhibition *Dialogue: Stephen Procter and friends* was held at Quadrivium in Sydney the following year, featuring Procter's glass and drawings along with a body of complementary work from selected students and friends. Each had been given one of Procter's blanks and invited to make a gesture of personal expression to celebrate the life and work of this well-loved and exceptional man. Proceeds from the sale of work went towards the establishment of The Stephen Procter Fellowship, to provide an annual international mentorship scholarship for emerging glass artists.[80] Moje's piece, a deeply wheel-carved vessel, was acquired by the Art Gallery of South Australia.

For almost a decade the Canberra glass community had been lobbying the ACT Government for funding to establish a community-based glass studio within the Canberra urban environs. Given the prestige of the Canberra School of Art Glass Workshop and the acknowledged international profile of its alumni, the historic loss of graduates – who were obliged to move interstate and overseas to progress their practice – had long translated into a rather foolish waste of a valuable local asset. Back in 1993, glass artist Lienors Allen (now Torres) with the help of her father Richard Allan (himself an arts

79 To quote the award ceremony's official program.
80 Contemporary jeweller/glass artist Blanche Tilden was the inaugural recipient in 2003.

The studio/house at Wapengo.
Photographer: Nigel Noyes

Moje laying out *Floating Red* (page 102) in his studio.

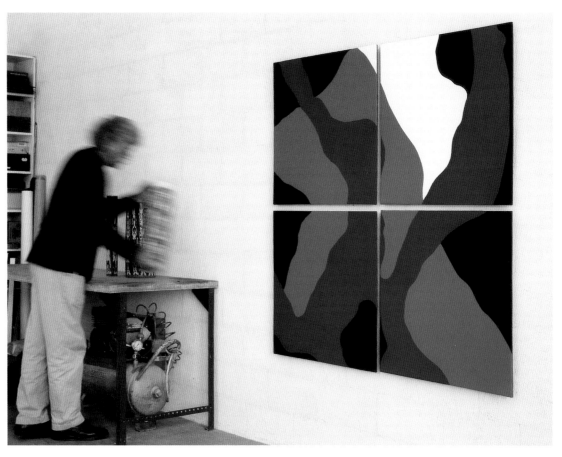

2002 | **Hsin Chu Blue** (wall-piece)
150 x 150cm
Collection of the National Gallery of Australia,
Canberra
Photographer: Nigel Noyes

It has always been a pleasure to run into Klaus at conferences, exhibitions, and all those other places where friends and colleagues do run into one another. His pleasure in meeting people must be at the heart of a belief that good friendships also make professional networks, and he has demonstrated this interest over many years in working hard to set up opportunities for others to make their own similar connections.

There are two occasions that stand out for me. The first was the opportunity to work first-hand with him when the National Gallery of Victoria's retrospective exhibition of Klaus's work came to the Powerhouse Museum in 1995. Although Geoffrey Edwards had done all the research and selection, we were involved in designing a space for the exhibition and presenting it to our Sydney audiences. Our designer, Angelina Russo, wanted to try backlighting the plates in a dark wall panel. This had not been tried before and, as many of the plates included strong opaque colours as well as some transparent ones, we were not sure it would work. Klaus had been used to each one displayed separately and free-standing. He generously allowed us to test the idea on light tables in the photography department and agreed to give it a go. As it turned out, the plates glowed seductively and, with the addition of a video showing his process of working to the sound of a slow saxophone and a 'process' case showing sheets and strips of glass and the moulds for kiln-forming, the result was spectacular. He was generous in his collaboration with all our staff and in the acknowledgement of their roles.

Secondly, in 2001, we both discovered that we were 'it' for the Visual Arts/Craft Board's Emeritus Awards for that year: Klaus with the artist's award and me with the medal. Over many years all our paths converge and diverge considerably, but we know we are all working towards the same ends and value the links we make along the way. I think we both enjoyed the fact that we were on that stage at the same time, on that particular occasion. I know I did.

Grace Cochrane
Former Senior Curator, Australian Decorative Arts and Design, Powerhouse Museum, Sydney

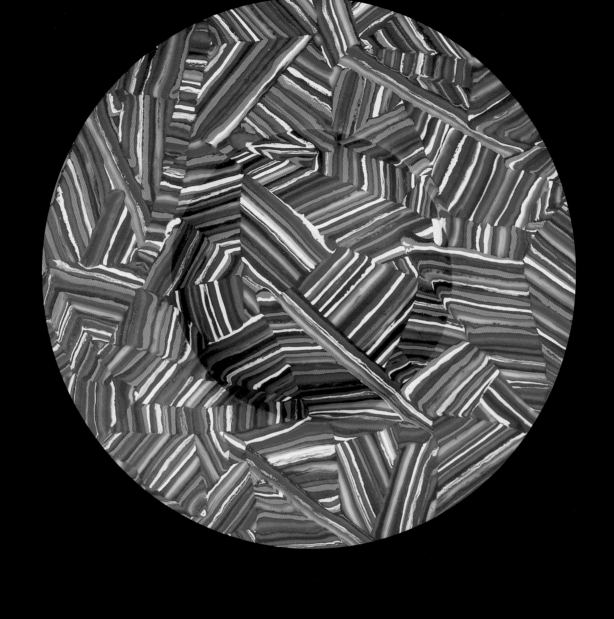

2001 **Untitled**

(from the 'Fragments' series)

7.5 x 53 x 53cm

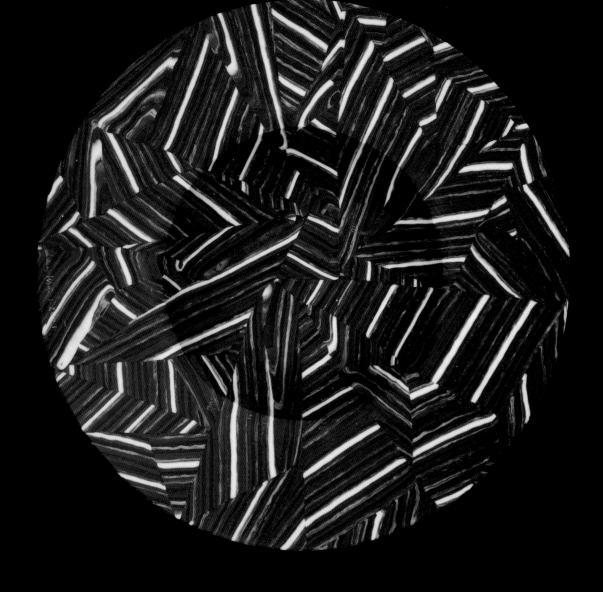

2002 | **Untitled**
(from the 'Fragments' series)
7.5 x 53 x 53cm
Collection of the National Gallery of Australia, Canberra

administrator) wrote the original document of submission that was duly presented to the then Chief Minister Kate Carnell. Carnell's positive response led to a meeting with a working group that included Allan, Stephen Procter, Itzell Tazzyman and Kirstie Rea. A further submission for the funding of a feasibility study was sent to the Department of Education, resulting in a grant of $20,000 to be administered through Craft ACT's Director Jenny Deves. The ensuing out-sourced study returned, to everybody's horror, a negative finding; at which juncture Deves and Moje (who was by this stage serving on the Management Committee of the Crafts Council of the ACT) stepped in to re-negotiate with Carnell. After much persuasion they managed to bring the project back on track. (The 'rescue and negotiation' scenario would again be revisited further down the track, courtesy of a subsequent election and change of government.) [81]

There followed the drawn out systemic processes of interminable bureaucratic and corporate consultancy, throughout all of which the sheer dedication of the faithful kept the flame alive. It took years of massaging the project through the mires of governmental minutiae, until in 1999 it started to firm up into a tangible reality when the government, through the ACT Cultural Council, at last brought architects into the picture. The moiling was far from over but there was finally glass at the end of the tunnel. As Procter's health declined, Moje had been taking on more of the advisory responsibilities. By 2002 the Glassworks project, having finally found a home at the old Powerhouse on the Kingston foreshore, was devouring increasing time and attention.

That year Moje travelled to Germany to deliver the annual lecture at the TDK Seminar;[82] had a solo at Axia Modern Art in Melbourne; was featured in *Facets of Australian Glass*, Leo

Kaplan Gallery, New York; and was included in two exhibitions curated by the National Gallery of Australia's Curator of Decorative Arts, Robert Bell, *Material Culture* at the National Gallery of Australia and *Transparent Things* which had opened at the Wagga Wagga Art Gallery and later travelled to the Broken Hill City Art Gallery in regional New South Wales, the Geelong Art Gallery and the Gippsland Art Gallery in regional Victoria, and the Craft ACT Gallery in Canberra.

But in 2003 Moje was brought to a screeching halt, in a most terrible and literal manner. Run off the road by a reckless driver he crashed down an embankment into dense bushland, sustaining severe injuries. He was lucky to be found, lucky to be alive, but not so lucky as to escape three long months in hospital followed by another six in convalescence. With his fitness in doubt even in the medium-term, he had to cancel all present and future exhibiting commitments and, while able to direct some of his business from his daybed at Wapengo, he found himself confined to the all-important duty of recovery. He was also obliged to step back from his manifold committee obligations, most particularly the proactive, time-consuming work on the steering-committee for the Glassworks at Kingston. This he handed over to the recently appointed Head of the Australian National University Glass Workshop,[83] Richard Whiteley, though Moje would re-enter the picture later in a key advisory role as time and health permitted.

One of the few exhibitions that did go ahead was *The Glass Vessel* at the Kentucky Museum of Art and Design, as the work was already organised and Chaseling was able to step in to deliver the accompanying lecture on Moje's behalf. Moje, unsurprisingly, fretted about the loss of time and was disappointed to have to cancel a workshop at North Lands Creative Glass in Scotland. At last, however, he was given

111

81 At which point Bill Woods, the new Minister for the Arts, and Mandy Hillson and John Stanwell from Arts ACT facilitated the project.

82 TDK was a major German glass distribution company.
83 The Canberra School of Art was amalgamated into the Faculty of the Arts at the Australian National University in 2004.

one reprieve. Towards the end of the year he had sufficiently recovered to take up a programmed artist-in-residence session at Nagoya Arts University, Japan. There he ran a kiln-fusing workshop and managed to make two wall-pieces. How happy he was to be back on his feet in the workshop at last.

In 2004 Moje was out and about, just a little more sedately perhaps.[84] At a black-tie event in New York he received the UrbanGlass Lifetime Achievement Award in recognition of his contribution to the international glass movement, and the following day was treated to a surprise opening at the Lehmann Gallery:[85] *Klaus Moje: A Life in Glass*, a retrospective exhibition curated by David Revere McFadden.[86] It was totally unexpected – the VIP opening and exhibition had been planned entirely without his prior knowledge. From New York he travelled to Pilchuck to teach a kiln-forming workshop in a session that marked 25 years of association, and at *SOFA-Chicago* he had a solo show with Heller Gallery and gave a public lecture entitled 'Views from the Top, Over and Down Under: a Quarter Century of Glass Art and Education in Europe, the US and Australia'. He was included in *Studio Glass International: Selections from the Esterling/Wake Collection*, at the Marxhausen Gallery, Concordia University, Nebraska, and the New Contemporary Glass Gallery at the Victoria and Albert Museum, London. Back in Australia, he showed work at the opening of a small and unpretentious country gallery, Ivy Hill Studio, Wapengo, and made trophies for the local Tathra 'Wharf to Wave' ocean swim event.[87] Moje is nothing if not egalitarian.

At the 2005 GAS Conference, held in Adelaide (which focused every glass eye in the antipodes on the JamFactory and its surrounds), Moje saluted the advent of his fast-approaching golden jubilee with the lecture 'Spotlights: 50 Years After and Everything in Between'. The reference to professional longevity certainly conveyed an implicit gravity, but not with any sense of impending endplay. For Moje a 50-year milestone merely furnished him with an opportunity to pause and take stock, to re-gather his orientation and resolution for the next foray. While the passage of time and the respect of colleagues may well have conferred upon him the role of venerable grandee of kiln-formed glass, in terms of his own practice he considered himself just on the cusp of full bloom; as he said in the lecture, he was 'coming to a point in (his) work where the balance between creativity and skill has become the ultimate test'.[88] The work, in fact, was becoming progressively more expressive and expansive, and he and the glass were continuing to develop an ever-growing appetite for that wall.

Shortly after the Adelaide conference he gave another lecture at 'Becon' in Portland,[89] and then made a grand tour of his old European haunts with Enders. This would be the first vacation of sorts that he'd allowed himself for decades and – between teaching a Master workshop at North Lands,[90] Scotland, visiting the Victoria & Albert Museum in London and generally pressing the flesh around the European glass community – they found time to share a little romance in Paris and meander down his boyhood memory lane, 50 kilometres east of Dresden.

On the exhibition front he showed in *Dual Vision – the Simona and Jerome Chazen Collection* at the Museum of Arts and Design, New York; *Seeds of Light*[91] at the ANU School of Art Gallery, Canberra; *Symbiosis: The Professional Intimate*[92] at the Kamberra Glass Gallery, Canberra; *Transformations: The language of craft*, at the National Gallery of Australia, Canberra; and at Axia Modern Art, Sydney. The noteworthy news of the year was the granting of an Australia Council Fellowship which

84 Though he himself doesn't view this as a necessarily bad thing. The slower pace has translated into an even more fulsome consideration of each piece while he works. (Klaus Moje, in interview with Megan Bottari.)
85 The UrbanGlass gallery.
86 Chief Curator of the Museum of Arts & Design, New York.
87 He made two trophies – one each for the winning male and female in the 2004 Travelworld Bega 1200m Splash for Cash. The Tathra Wharf to Wave day is an annual fundraising event.
88 Klaus Moje, 'Spotlights' speech at the GAS Conference, Adelaide, 2005.
89 The Bullseye Connection Conference.
90 To make up for the one he missed in the year of the accident.
91 An exhibition celebrating 20 years of graduates from the ANU (Canberra) School of Art Glass Workshop.
92 One of those rare exhibitions with Enders.

2002 | **Untitled**
5 x 44 x 44cm

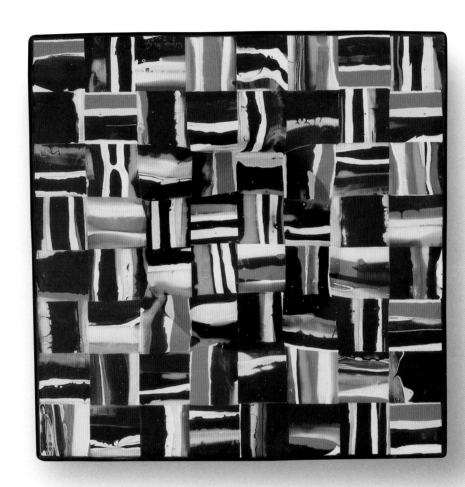

2002 **Untitled**
5 x 44 x 44cm

I first became aware of Klaus Moje's exceptional work when I was the curator at the Cooper-Hewitt National Design Museum in New York. I was immediately struck by the sheer visual power of his composition and sense of colour. For the museum I acquired a work from his dealer in Germany, an octagonal bowl with fused strips of the deepest cobalt blue and a rich translucent red. When the bowl was displayed against a light, the colours literally vibrated in their intensity. In more subtle light one was aware of the delicate tactility of the wheel cut surfaces. Klaus had achieved in this work a perfect synthesis between the visual and the tactile, and from that point forward I was determined to keep abreast of his career.

Now over 20 years later I continue to be inspired and challenged by the perennial evolution of ideas in Klaus's work. When I came to the then American Craft Museum (now we are the Museum of Arts & Design) in 1997, I put Klaus's name on my wish list of works for the collection. Thanks to Klaus and Heller Gallery, we were able to acquire a spectacular bowl in black, green, red and yellow, which toured with an exhibition organised by the museum, Defining Craft, for over three years. When UrbanGlass chose Klaus as the recipient of their Lifetime Achievement Award, I was asked to organise a retrospective of his work, a duty that I accepted with the greatest pleasure. With loans from the most prominent collectors of Klaus's work, we assembled a stellar overview of one man's creative journey over time and space, all captured in the unique forms, colours and patterns of Klaus's unique objects.

In this survey, which provided a landscape of Klaus's work over the decades, I began to see more clearly the relationship between nature and art as embodied in Klaus's glass. Light and landscape are recurring themes in Moje's fused glass. His early highly patterned mosaic works explored the ways in which color is affected by light, ranging from densely opaque passages to radiantly translucent and jewel-like colours. Klaus's perceptive eye soon discovered the stern beauty of Australia's landscape and rich cultural history. He translated these impressions into ribbons of coloured glass that suggest the Australian horizon, sometimes using patterns inspired by the ceremonial objects created by the country's indigenous people. Further explorations of geometry and juxtaposed pattern and form led the artist to transform his disciplined geometric forms into rich painterly canvases that explode with colour and vibrate with rhythmic gesture.

Klaus Moje's work immediately engages the eye through his masterful use of colour and pattern. However, the impact of his glass is not only visual. Klaus shares intimate glimpses of his world, his memories and his visions as tangible poetry.

Klaus is artist, poet, and, to my continued gratification, a wonderful friend and colleague.

David Revere McFadden

Chief Curator, Museum of Arts & Design, New York

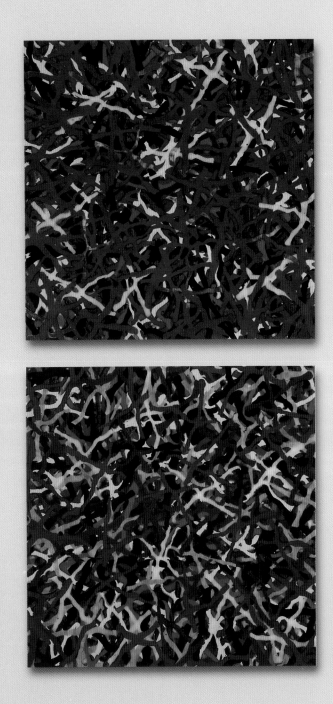

2002 **Nagoya** (wall-piece)
150 x 75cm

would provide a sufficient financial bolster to enable him to focus entirely on the next planned Moje opus – *Klaus Moje: Glass*, the second of Object Gallery's 'Living Treasures: Masters of Australian Craft' exhibitions.

In 2006 Moje was awarded the distinction of Honorary Officer (AO) in the General Division of the Order of Australia. It was the one distraction he allowed himself in a year that was otherwise entirely concentrated on the upcoming 'Living Treasures' exhibition: selection for which was a laudatory deference that granted a generous degree of creative privilege. It provided an opportunity that gave him licence, in effect, to explore his idiom without constraint, in a show that by its own definition called for an overt display of artistic virtuosity. It had often been his wont, over the years, to use the analogy of swimming in the context of the development of his work, particularly in terms of overcoming the limitations and resistance of the material. As he reflected in his speech at the GAS Conference earlier that year:

> When I was a child and wanted to swim I got adventurous and left the swimming aide, then struggled to hold myself above the water. After that came the years when I reached out and swam with confidence. But there was a point when I started to do competitive swimming and entered a real training program; it was then that suddenly I was not swimming in the water any more, but above it – starting to glide. In applying this to our work we strive for a time when technique becomes the basis that allows the creative mind to flow.[93]

The works in the 'Living Treasures' exhibition, specifically the wall-pieces, have surpassed the gliding. They soar instead, in exquisitely crafted gestures of pure and uninhibited eloquence. Ever larger, ever more considered, ever more celebratory. Astonishingly the work conveys an added depth of presence, as if Moje and the glass, through the decades of shared experience and emotion, have reached some further point of intimate accommodation where the sensibility of the craft has progressed well beyond the merely painterly. Moje has now mastered his technique so effectively that, as a structure, it has been entirely subsumed by the strength and conviction of his artistic expressionism. What now emerges most succinctly in the Moje oeuvre is the new, commanding status of the wall-pieces. While the mosaic forms undeniably retain a strident voice, and indeed emanate an enriched and ever-maturing self-possession, in many ways they have become the support act for the main event. Moje has reached a point in his career where he requires a weightier canvas to fully convey his sense of the world. One suspects that the object will graciously retire to the passive role of detail, or inflection, for the broad and expansive view now afforded by the increasingly seductive larger work.

At the writing of this monograph, Moje was showing work in an exhibition entitled *Material Matters* at the Los Angeles County Museum of Art, Los Angeles, USA. It's a title that accurately reflects the abiding credo of his five decades of artistic practice. Indeed, when one casts back across a career's worth of Moje lectures and interviews one is struck by his enduring and faithful relationship with, and unwavering commitment and respect for, this most beloved material:

> I always try to give glass another facet, to let it appear even more beautiful than I see it as a raw material. The

117

2002 | Moje hand-grinding one of the wall-pieces in Nagoya, Japan.

93 Klaus Moje. 'Spotlights' speech, GAS Conference, Adelaide.

challenge of the material is part of what I try to incorporate in my expressions. There is also the ability for glass to let you have insight into the piece itself. It lets the eye in, through its transparency and translucency. I am fascinated with this, and even when I work with a panel that may not obviously be transparent I have the ability to get a feeling of depth into the piece by using layers of glass with overlays of transparency. This you cannot achieve with any other material. [94]

There is, moreover, a devotional sentimentality that he's perfectly comfortable about revealing, evidenced here in the acceptance speech given at the GAS Lifetime Achievement Award in 2000:

As for glass, I believe glass loves me. My whole life has circled around this wonderful material. I have never considered working with any other material and I am even reluctant about mixed media – I respect it, but it is not for me. I never feared glass, either. It is always referred to as seductive, but I like to be seduced! ... I believe that my work in Australia has matured to a point where I can say it is my best. I can now see what my artistic expression can produce in glass, and I know that my focus is glass and will always be glass. This is my choice, this is my material and, as I said, I am in love with it.[95]

Back in 1976, at the World Craft Council at Oaxtepec, Mexico, Moje, in another stirring 'table thumping' speech vis-à-vis that hoary old chestnut the art-versus-craft debate, had been extraordinarily prophetic: 'Surely one day we shall see objects in glass at the *Venice Biennale* or at *Documenta* in Kassel, but they will be standing there not because they are glass – no, because they will be art!'[96] Moje had in due time taken his art to Venice, and the elevation of the glass from the plinth to the wall is nothing short of the inevitable resolution of that long sought ambition. For Moje, it was always a matter of restoring glass to its rightful place in the artistic scheme of things.

While the 'Living Treasures' exhibition has a life of its own, out on the road touring Australia and the United States for the next three years, Moje in the meantime will be back in his studio surrounded by a gaggle of vessels and forms, all keenly vying for his attention for their chance of reflected glory on the wall. In a conversational aside during my recent interview while researching this book, Udo Sellbach had mused that he had always thought 'it would be interesting to see where Moje would go to soften that earlier geometric avant garde sensibility in his work, to melt the glass into design forms that are free.' Moje's current work, one would venture, is without doubt the most effusive and definitive reply.

The essential things in life 1 –
diving at Aragunnu, far south oast of New South Wales.
Photographer: Henry Halem

The essential things in life 2 –
Brigitte and Klaus at home, in Wapengo.
Photographer: Nigel Noyes

94 Klaus Moje, interview with Jacqueline Gropp in *Craft*,
 the magazine of Craft Victoria, Vol 30. No 239. 1/2000. p 10.
95 Klaus Moje, 'Glass Art Society Awards', *GAS Magazine*, 2000,
 pp 49-50.
96 *Glass* magazine, Volume 5, No 3, 1977, p 39.

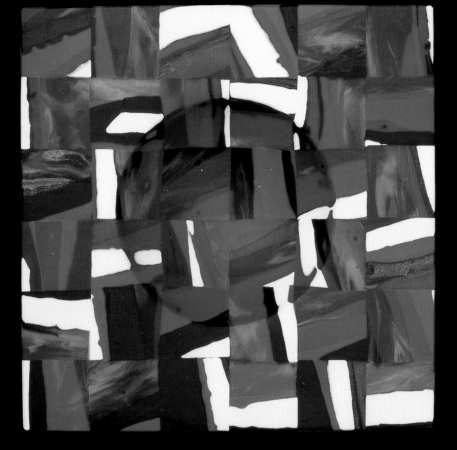

2003 **Untitled**
5 x 44 x 44cm

120

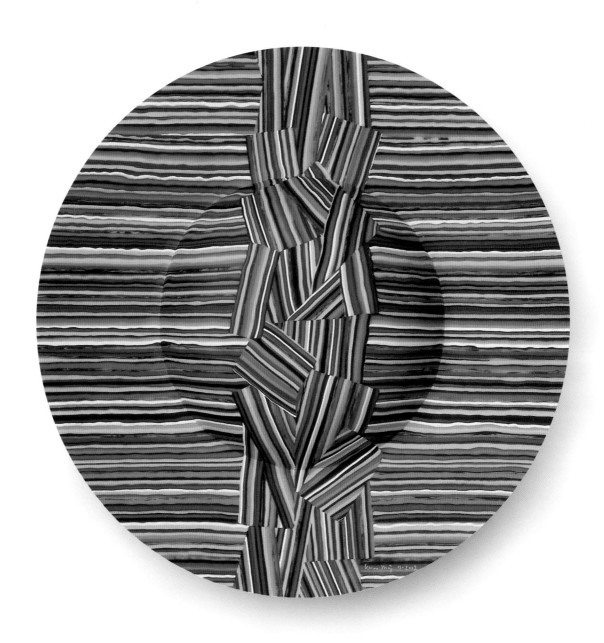

Untitled
(from the 'Penetrating' series)
7.5 x 53 x 53cm

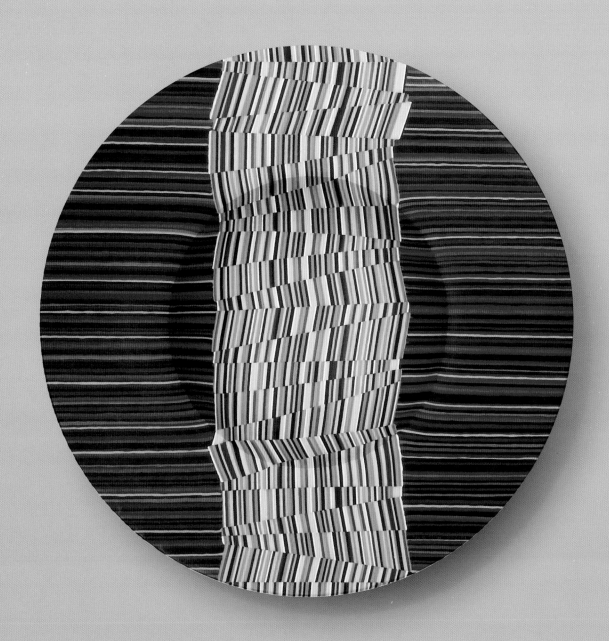

2003-05 **Untitled**
 ((from the 'Penetrating' series)
 7.5 x 53 x 53cm

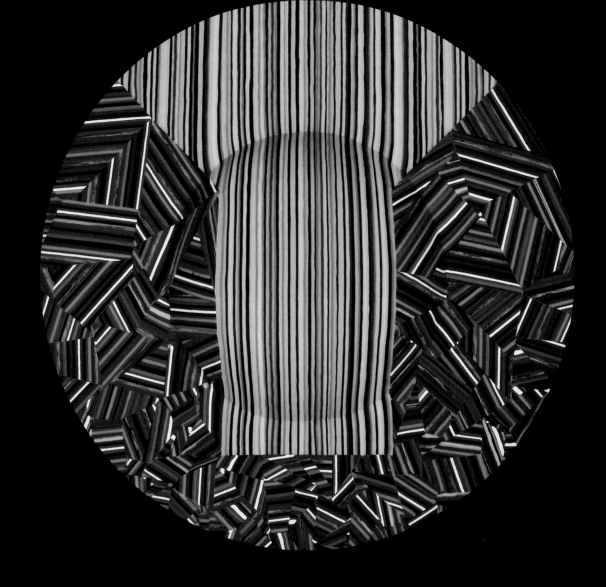

2003-05 | **Untitled**
(from the 'Penetrating' series)
7.5 x 53 x 53cm

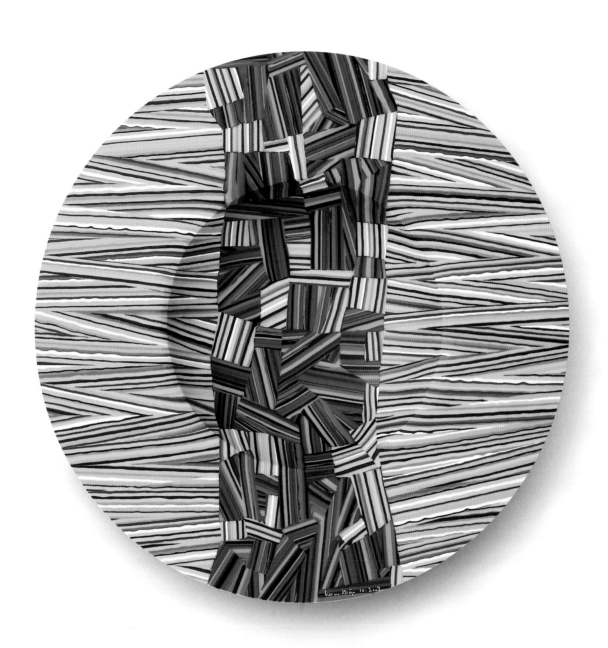

2003-05 **Untitled**
(from the 'Penetrating' series)
7.5 x 53 x 53cm

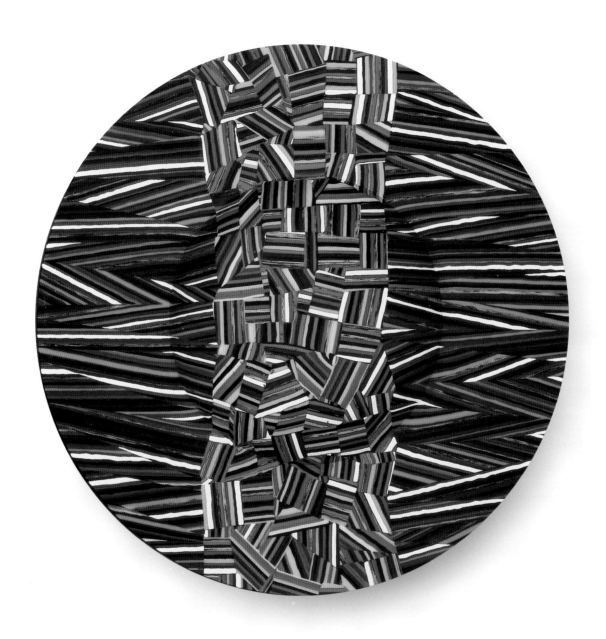

2003-05 **Untitled**
(from the 'Penetrating' series)
7.5 x 53 x 53cm

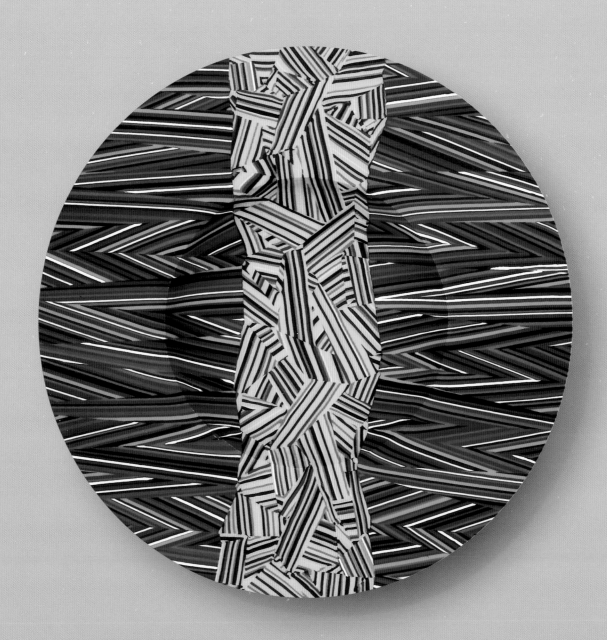

2003-05 **Untitled**
(from the 'Penetrating' series)
7.5 x 53 x 53cm

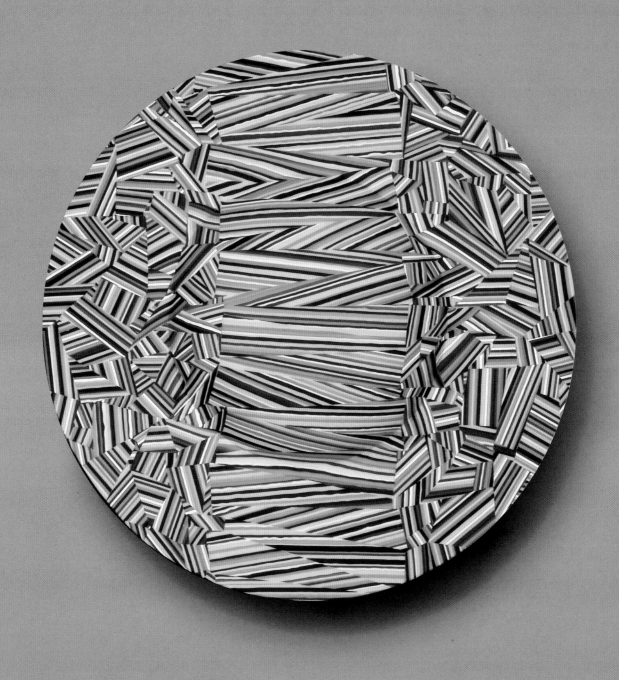

2003-05 **Untitled**
(from the 'Penetrating' series)
7.5 x 53 x 53cm
Collection of the Victoria & Albert Museum, London

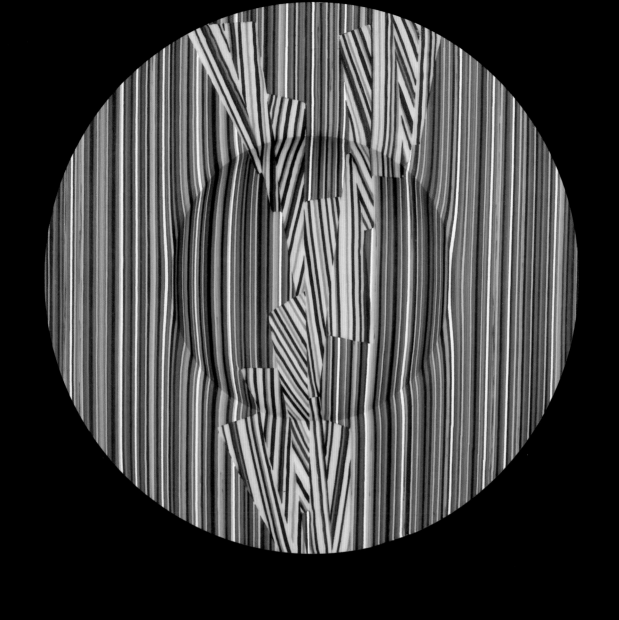

2003-05 **Untitled**

(from the 'Penetrating' series)

7.5 x 53 x 53cm

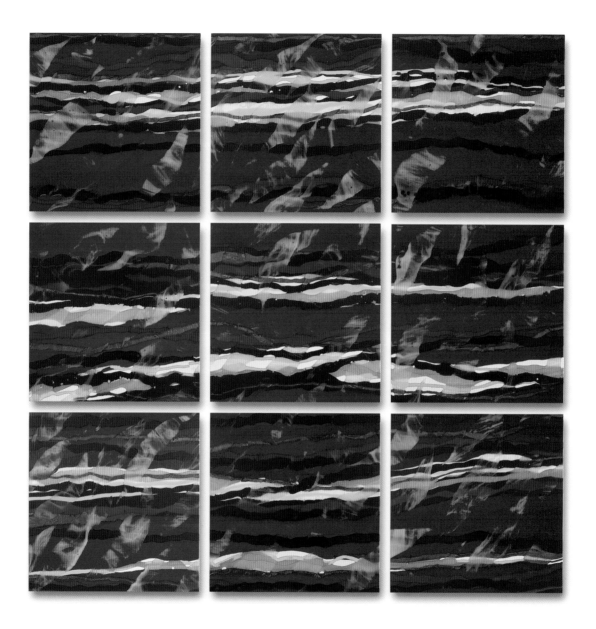

2006 **Untitled** (wall-piece)
150 x 150cm
Collection of Bullseye Glass Company

We forget only too easily which impulses the art of the past can give us when we experience it as a living presence. Properly understood, tradition becomes a force for the future. Bestowing the title of 'Living Treasure: Master of Australian Craft' on Klaus Moje once more provides an occasion to bring this to mind.

Klaus is rooted in his craft and through his craft he became an artist, in accordance with Goethe's realisation that many a good painter was once an efficient pigment grinder. Colour, the medium of the painter, is identical with illuminated glass for Klaus. His works up to 1965 were coloured glass windows, which are the fruits of his apprenticeship years. In the second group of his works the three-dimensional form took centre stage. He cut glass into powerful vessels with plastic qualities, and prepared himself, like a journeyman, for the mastery that made him the undoubted leading artist in mosaic glass today.

In Hamburg around 1975 he presented his first vessels in an old Roman technique, renewed by him; they became a sensation for all who know glass – both its history and its present. This technique of melting and cutting vessels from coloured rods had all but been forgotten for some 16 centuries; the only exception was the mille fiori glass of the Venetian workshops. Trivialities, restricted to petty variations, seemed obsolete to Klaus Moje. He melted his vessels from stronger glass strips whose scale possessed subtle nuances at the same time. He aimed for a clear structure, a tectonic ornamentation, right from his first steps, for a change of distinct contrasts, but each area remaining lively and modulated in itself. He handled the glass elements like a painter handles his paints and understood the form of his vessels at the same time like a sculptor his volumes.

That his method was only viable with losses bothered him no more than another great glass artist a century before: Émile Gallé liked to show his visitors mountains of fragments, the result of his work, which was never quite predictable. Some years ago I saw a similar pile of failed attempts at one of the great Japanese masters of celadon ceramics on Kyushu. Who strives for the ultimate must not avoid risk. I am happy that I could experience how decisive Klaus Moje approached this risk three decades ago and how he now receives his reward as high recognition in his new home country.

Professor Dr Heinz Spielmann
Former Director of the Landesmuseums auf
Schleswig Holstein, Germany

129

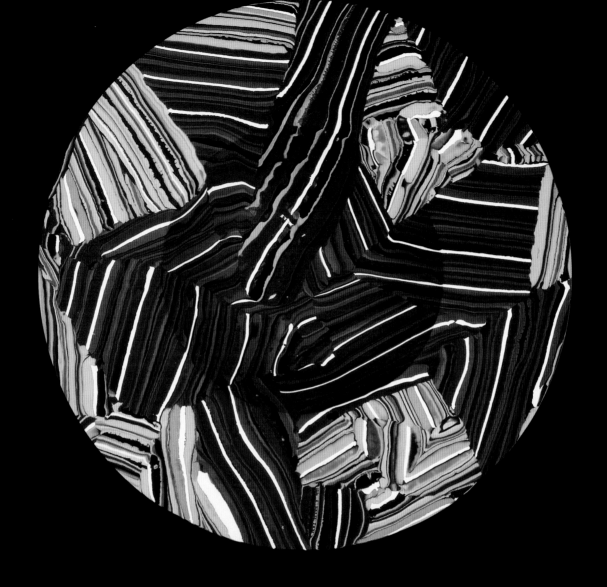

2006 **Untitled**

7.5 x 53 x 53cm

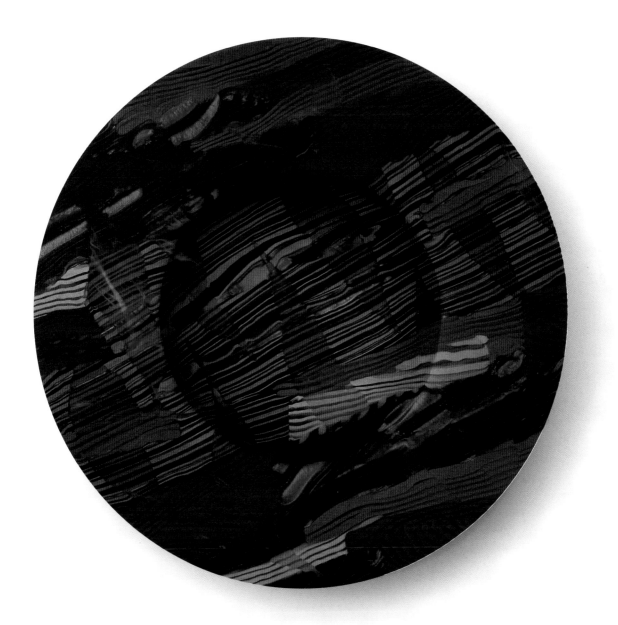

131

Untitled
7.5 x 53 x 53cm

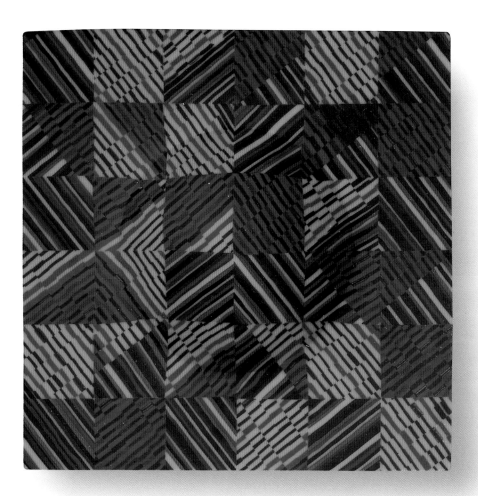

2006 **Untitled**
5.5 x 30 x 30cm

2006 | **Untitled**
7.5 x 53 x 53cm

Thank you.
The wave that I have been
riding for the last 50 years has been leading
me through motions of experiences that have included all
colours of life, but has never thrown me off the chosen path. Throughout
my life I have had the privilege to be surrounded by friends who guided
me, who added to my life, who were there when needed and shared risk and
excitement. All those mentioned and not mentioned in this book I want to thank,
because without you, I never would have made it. I want to thank my children
Jonas, Mascha, Amos and Danilo, to whom I wanted to be a good father and who I
see growing now into new family units; with Ute and granddaughter Feline and
grandson Philip; and Cameron and grandson Otto and expecting Esther.
Through all these years in Australia that have formed me, Brigitte was on
my side and stood in, filling the voids that I left and giving advice and
support through all those critical moments. Together we have
found the end of the rainbow here in Australia.
I thank you Brigitte and above all –
I love you.

Klaus

2006 **Untitled** (wall-piece)
150 x 150cm

Klaus Moje: Biographical Details

Klaus Moje

1936	Born, Hamburg, Germany
1952–55	Training as glass-cutter and grinder in the family workshop in Hamburg – attained Journeyman's Certificate
1957-59	Studied at Rheinbach and Hadamar glass schools – Master's Certificate
1960-61	Worked in industry and crafts
1961	Joint studio with Isgard Moje-Wohlgemuth
1961-65	Completed commissions for stained glass windows in churches and public buildings, including restoration work
1966	First work on container forms in painting and sculptural wheel-cutting
1969-73	Representative of the Arbeitsgemeinschaft des Deutschen Kunsthandwerks at the World Crafts Council and subsequently appointed to the Board of Directors
1971-76	Moved to Danziger Strasse, and founded the Werkstatt Galerie
1975	First work in mosaic glass exhibited
1976	Founding member of Galerie der Kunsthandwerker a continuation of the Werkstatt Galerie, Hamburg
1978-82	Member of Jury of *Arbeitsgemeinschaft des Deutschen Kunsthandwerks*
1979-	Guest lecturer Pilchuck Glass School, USA (repeatedly); Arts and Crafts School, Copenhagen, Denmark; Royal College of Art, London, UK; Middlesex Polytechnic, London, UK; California College of Arts and Crafts, USA; Rietveld Academy, Amsterdam, Holland; Kent State University, Kent, USA; UrbanGlass, New York, USA; Corning Museum of Glass Studio, New York, USA; Ezra Glass Studio, Kanazu, Japan; North Lands Creative Glass, Scotland; Nagoya Arts University, Japan

1980	Sole continuation of the studio in Hamburg
1982	Arrival in Australia with partner Brigitte Enders
1982-91	Founding Head of Glass Workshop, Canberra School of Art, Australian National University
1987-88	Exhibition Coordinator for Crafts Council of the ACT, Canberra
1988	Convenor of International Masterworkshop in Kiln-forming Glass Techniques, Canberra School of Art
1988-92	Served on several committees of the Visual Arts/Craft Board of the Australia Council
1989	Exhibition Coordinator *Kiln-formed Glass from Australia*, touring USA
1990-	Ebeltoft Glass Museum, International Advisory Committee
1992	Joint studio with ceramicist Brigitte Enders, Rivett, Canberra; Member of Management Committee, Crafts Council of the ACT
1992-93	Executive member of AusGlass
1993-	Pilchuck Glass School, International Advisory Committee
1994	Exhibition Coordinator, *Out of Canberra*, kiln-formed work of 13 glass artists, JamFactory, Adelaide, High Court, Canberra, Meat Market Craft Centre, Melbourne
1995-97	Board Member, Visual Arts/Craft Fund of the Australia Council.
1997-99	Member Art Advisory Committee, Parliament House Art Collection, Canberra
1997	First work at the Tanja studio UrbanGlass, New York, International Advisory Committee; Completion of major wall panel for ACT Legislative Assembly House, Canberra; Artist-in-residence, Niijima, Japan, (made first rolled hot worked forms, called 'Niijimas' in future)

1998	Relocation of studios to Wapengo, New South Wales; Demonstration and lecture, GAS Conference, Seto, Japan; Continuation of 'Niijimas' with gaffer Scott Chaseling; Member of Craft ACT Management Committee
1999	First showing of 'Niijima' roll-ups, New York
2000	Demonstration of 'Niijimas', GAS Conference, New York; Artist-in-residence, Pilchuck; Lecturing and workshop, Academie, Munich and Zwiesel Glafachschule
2001	Demonstration and lecture, Hsinchu Municipal Glass Museum, Hsinchu, Taiwan; Lecture, Grand Cristall Museum, Taipei, Taiwan; Lecture and workshop, Nagoya University of Arts, Japan
2003	Artist-in-residence, Nagoya University of Arts, Japan
2004	Lecture, 'Becon' Conference, Portland, USA
2005	Masterworkshop, North Lands Creative Glass, Scotland
2006	Lecture and demonstration, GAS Conference, Adelaide, Australia

Solo Exhibitions

1973 Artist-Craftsmen in Europe, British Crafts Centre, London, UK*

1979 Contemporary Art Glass Gallery, New York, USA

1980 Retrospective, Museum für Kunst und Gewerbe, Hamburg, Germany*

1981 Foster/White Gallery, Seattle, USA
Habatat Galleries, Detroit, USA (repeatedly)
Heller Gallery, New York, USA (repeatedly)
Galerie Lietzow, Berlin, Germany

1982 Galerie SM, Frankfurt, Germany

1985 Glass Artists Gallery, Sydney, Australia
Kurland/Summers Gallery, Los Angeles, USA (repeatedly)
John Kuhn – Klaus Moje – Richard Ritter, Glass Art Gallery, Toronto, Canada

1986 Structure and Colour: Fused glass forms, Heller Gallery, New York, USA

1987 Devise Gallery, Melbourne, Australia
Habatat Galleries, Miami
Boca Raton, Florida, USA (repeatedly)

1989 Sanske/Zimmermann Gallery, Zürich, Switzerland (repeatedly)

1991 Dale Chihuly – Klaus Moje, Ebeltoft Glass Museum, Ebeltoft, Denmark*

1992 Nikki Gallery for Contemporary Art, Tokyo, Japan

1993 Cinaf Chicago, USA (Solo show with Habatat Galleries)

1994 Composition Gallery, San Francisco, USA

1995-96 Klaus Moje: Glass/glas, a retrospective, National Gallery of Victoria, Melbourne, Australia*; Powerhouse Museum, Sydney, Australia; Canberra School of Art Gallery, Canberra, Australia; Museum für Kunst und Gewerbe, Hamburg, Germany; American Craft Museum, New York, USA; Wustum Museum of Fine Art, Racine, Wisconsin, USA

1996 Seattle Art Fair, Seattle, USA (with Ruth Summers Gallery)

1997 Klaus Moje – Recent Work, Craft ACT Gallery, Canberra

1998 Axia Modern Art, Melbourne

2000 SOFA-New York, USA (with Bullseye Gallery)

2001 Klaus Moje Art Glass, Hsinchu Municipal Glass Museum, Hsinchu, Taiwan*
SOFA-Chicago, USA (with Habatat Galleries)

2002 Axia Modern Art, Melbourne Australia

2004 SOFA-Chicago, USA (with Heller Gallery New York)

2006 'Living Treasures: Masters of Australian Craft'
Klaus Moje: Glass, Object Gallery, Sydney

Group Exhibitions

1969 Biennial of European Decorative Art, Stuttgart, Germany*

1970 Werkstoff und Form, Fockemuseum, Bremen, Germany*

1973 Leading German Craftsmen, Rima Vera, Cambridge, UK
Ceramic Art of the World, Calgary, Canada*

1974 In Praise of Hands, World Craft Council, Toronto, Canada*
Six German Glass Artists, Kilkenny, Ireland; Goethe-Institut, Munich (travelling North and South America and Australia)*

1976 Modern Glass Made in Europe, USA and Japan, Frankfurt*

1977 Coburg Glass Prize, Kunstsammlungen der Veste Coburg, Coburg, Germany*

1978 Deutsche Glaskünstler Heute, Interversa, Hamburg, Germany (travelling)*
German Glass Today, (worldwide travelling exhibition)*

1979 New Glass – A Worldwide Survey, Corning Museum of Glass, New York, USA*

1980 German Glass and Silver, Landesmuseum, Karlsruhe, Germany*
Contemporary Glass – Europe and Japan, Museum of Modern Art, Tokyo and Kyoto, Japan*

1981 Glass 81 in Japan, Tokyo, Japan (invitational)*
Pilchuck Glass, Anchorage, Alaska, USA
Glaskunst 81, Orangerie, Kassel, Germany*
World Glass Now '82, Hokkaido Museum of Modern Art, Japan*

1982 International Directions in Glass Art, Art Gallery of Western Australia (touring Australia)*

1983 Glass in Germany, Kunstmuseum Düsseldorf, Germany*
Nippon Gendai Kogei Bijutsu, Japan (invitational)*

1984 Triennale des Deutschen Kunsthandwerks, Frankfurt, Germany*
Glass 84 in Japan, Tokyo and Kobe, Japan (invitational)*
Deutsche Glaskünstler (touring Germany)*
Nine Artists in Glass, Snyderman Gallery, Philadelphia, USA
Material and Form, Metiers d'Art en Allemagne, Paris, France*
Samlingen of Moderne International Glaskunst, Ebeltoft, Denmark*

1985 Second Coburg Glass Prize, Coburg Castle, Coburg, Germany*
World Glass Now '85, Hokkaido Museum of Modern Art, Hokkaido, Japan (invitational)*
Guest Exhibitor, annual show of New Zealand Glass Artists Auckland, NZ
Third National Biennial Glass, Wagga Wagga, NSW, Australia
The Pilchuck Exhibition, Habatat Galleries, Detroit, USA

1986 Ella Sharp Museum, Grandrapid Museum, Krasl Art Centre and Midland Center for the Arts, USA
Saxe Collection, Oakland Museum, San Francisco, USA*

139

1987 *Form and Function,*
Meat Market Craft Centre, Melbourne,
Australia
New Expressions with Glass,
Hunter Museum, Chattanooga, Tennessee, USA
Triennale des Deutschen Kunsthandwerks,
Frankfurt, Germany; Hesinki, Finland*

1987-88 *Thirty Years of New Glass, 1957-1987,*
Corning Museum of Glass, Corning, and the
Toledo Museum of Art, Toledo, Ohio, USA*

1988 *Glass from Canberra,*
Despard Street Gallery, Hobart, Australia
Over Here,
Canberra School of Art, Canberra, Australia*
World Glass Now '88,
Hokkaido Museum of Modern Art, Hokkaido,
Japan (invitational)*
The New Aesthetics,
Habatat Galleries, Detroit, USA
European Decorative Arts,
Stuttgart, Germany
Contemporary Art Glass,
Boca Raton Museum, Florida, USA

1989 *Australian Kiln-formed Glass,*
(travelling USA)
The Vessel: Studies in form and media,
Craft and Folk Art Museum, Los Angeles, USA
(invitational)
First Perth International Crafts Triennal,
Art Gallery of Western Australia, Perth*
The New Aesthetic,
Habatat, Boca Raton Museum, USA

1990 *International Glass Exhibition,*
Kanazava, Japan*

1991 *World Glass Now '91,*
Hokkaido, Japan*
Triennale des Norddeutshcen Kunsthandwerks,
Schloss Gottorf, Schleswig, Germany*
Masters of Contemporary Glass,
Naples Museum, Naples, Florida, USA

1992 *National Craft Award,*
Melbourne, Australia (invitational)
Australian Crafts: New Works 1988-1992,
Powerhouse Museum, Sydney
Rufino Tamayo Museum, Mexico City, Mexico
2nd Perth Triennial,
New Directions in Glass Art, Perth, Western
Australia*
International Kiln-formed Glass,
Portland, USA*
A Decade of Studio Glass,
Morris Museum, New Jersey, USA
Contemporary Internatinal Studio Glass,
Monterrey, Mexico

1994 *Glas-objecte von Kuenstlern aus Aller Welt,*
Hergiswil, Switzerland
International Survey of Contemporary Glass,
Concept Art Gallery, Pittsburgh, USA
Pieces of Importance,
Crafts Council of ACT, Canberra, Australia
(invitational)
Out of Canberra,
JamFactory, Adelaide; High Court, Canberra;
Meat Market Craft Centre, Melbourne, Australia

1995 *Latitudes 2,*
Crafts Council of the ACT, Canberra,
Australia*
Hsinchu International Glass Art Festival, Taiwan

1996 *Venezia Aperto Vetero,*
Venice, Italy (invitational)*
Art in Glass '96,
Editions Galleries, Melbourne, Australia
Galerie L, Hamburg, Germany
From Venice to Ebeltoft,
Ebeltoft Glasmuseum, Denmark

1997 *International Contemporary Glass,*
Hsinchu Cultural Center, Taiwan
Drawing on the Diaphanous,
Michael Nagy Fine Art, Sydney
From Venice to Ebeltoft, Ebeltoft Glasmuseum,
Denmark
Australian Glass,
Galerie Rob Van Den Doel, Netherlands
Museo del Vidreo, Monterrey, Mexico
Via Venedig til Varberg,
Varberg, Sweden

1998 *Masters of Australian Glass,*
Quadrivium, Sydney, Australia
Latitudes 2,
Seto, Japan; Portland, USA; Canberra, Australia*
Gallery Enomoto, Osaka, Japan
Venezia Aperto Vetro,
Venice, Italy*
Contemporary Australian Craft,
Hokkaido Museum of Modern Art, Japan
(travelling Takaoka, Shiga and Australia)*

1999 *Meister der Moderne,*
Munich, Germany
SOFA-New York,
New York, USA (with Heller Gallery)
SOFA-Chicago,
Chicago, USA (with Habatat Galleries)
Passion,
Quadrivium, Sydney, Australia
Cheongju International Craft Biennale,
South Korea

2000 *Defining Craft,*
American Craft Museum, New York, USA
*Colonial to Contemporary: a decade of collecting
Australian decorative arts and design,*
Powerhouse Museum, Sydney, Australia
Shattering Perceptions,
Dennos Museum Center, Traverse City, Michigan,
USA; Museo del Vidreo, Monterrey, Mexico
On the Edge, Australian glass,
Gallery Handwerk, Munich, Germany;
Brisbane City Art Gallery, Brisbane, Australia;
Object Gallery, Sydney, Australia; National
Glass Centre, Sunderland, UK*
Contemporary Craft,
Collection of Powerhouse Museum, Sydney,
Australia*
Strength to Strength,
Craft ACT, Canberra, Australia

2001 *The Colour Red*,
 Exempla, Munich, Germany
 International Glass Exhibition,
 Shanghai Museum of Fine Arts, China
 International Glass,
 Millennium Museum, Beijing, China
 Milano Meets Canberra,
 Galleria Scaletta di Vetro, Milan, Italy
2001-02 *Transparent Things*,
 Wagga Wagga Regional Gallery; Broken Hill
 City Gallery; Geelong Art Gallery; Gippsland
 Art Gallery, Sale; Craft ACT, Canberra,
 Australia
2002 *Material Culture*,
 National Gallery of Australia, Canberra,
 Australia*
 Facets of Australian Glass,
 Leo Kaplan Modern, New York, USA
 Dialogue,
 Quadrivium, Sydney, Australia
 The Glass Vessel,
 Kentucky Museum of Arts and Design, USA
2004 *A Life in Glass a retrospective exhibition*,
 Lehmann Gallery at UrbanGlass, New York, USA
 Studio Glass International,
 Esterling/Wake Collection, Germany
2005 *Dual Vision – the Simona and Jerome Chazen*
 Collection,
 Museum of Art and Design, New York, USA*
 Seeds of Light,
 ANU School of Art Gallery, Canberra, Australia
 Transformations: The language of craft, National
 Gallery of Australia, Canberra, Australia*
 Axia Modern Art, Sydney, Australia
2006 *Collect*,
 Victoria & Albert Museum, London, UK
 Material Matters,
 Los Angeles County Museum, USA
 20 Years On, Glasmuseet Ebeltoft, Denmark

Public Collections

Art Gallery of Western Australia, Perth,
Australia
Auckland Museum, Auckland, New Zealand
Australian National University Collection,
Canberra, Australia
Badisches Landesmuseum, Karlsruhe, Germany
Bayerischer Kunstgewerbe-Verein, Germany
Canberra Museum and Art Gallery, Australia
Carnegie-Mellon University, Pittsburgh, USA
Chrysler Museum of Art, Norfolk, USA
Cincinnati Art Museum, Cincinnati, Ohio, USA
Cooper Hewitt Museum, New York, USA
Corning Museum of Glass, New York, USA
County Museum of Art, Los Angeles, USA
Den Hague, Gemendemuseum, The Netherlands
Detroit Institute of Art, USA
Fine Arts Museum of San Francisco, USA
Glasmuseet Ebeltoft, Denmark
Glasmuseum Frauenau, Frauenau, Germany
Grassi Museum, Leipzig, Germany
Hsinchu Cultural Centre, Taiwan
Kestnermuseum, Hanover, Germany
Kunstgewerbemuseum Darmstadt, Germany
Kunstgewerbemuseum, Berlin, Germany
Kunstgewerbemuseum, Köln, Germany
Kunstgewerbemuseum, Prague, Czech Republic
Kunstmuseum Düsseldorf, Germany
Kunstsammlungen der Veste Coburg, Coburg,
Germany
La Trobe University Collection, Melbourne,
Australia
Landesmuseum Oldenburg, Oldenburg,
Germany
Landesmuseum Schleswig Holstein,
Schleswig, Germany
Lobmeyr Museum, Vienna, Austria
Metropolitan Museum of Art, New York, USA
Minneapolis Museum of Art, USA
Mint Museum of Craft and Design, Charlotte, USA

Musée Art Decorative, Lausanne, Switzerland
Museum Am Heger Tor Wall, Osnabrueck,
Germany
Museum Bellerive, Zürich, Switzerland
Museum für Kunst und Gewerbe, Hamburg,
Germany
Museum of Art & Design, New York, USA
Museum of Modern Art, Hokkaido, Japan
National Gallery of Australia, Canberra, Australia
National Gallery of Victoria, Melbourne, Australia
Parliament House Collection, Canberra,
Australia
Nový Bor Museum, Czech Republic
Pilchuck Collection, Pilchuck, USA
Powerhouse Museum, Sydney, Australia
Queensland Art Gallery, Brisbane, Australia
Racine Art Museum, Racine, USA
Royal Scottish Museum, Edinburgh, UK
Samlingen of Moderne International
Glaskonst, Ebeltoft, Denmark
Seattle Art Museum, Seattle, USA
Schloss Cappenberg, Dorftmund, Germany
Shimonoseki City Art Museum, Japan
Staedtisches Museum, Goettingen, Germany
Toledo Museum of Glass, Toledo, USA
University of Wisconsin Art Collection, USA
Victoria & Albert Museum, London, UK
Wagga Wagga City Art Gallery, Wagga Wagga,
Australia
Wuerttembergisches Landesmuseum,
Stuttgart, Germany

Selections and Awards

1956 First prize in the *Competition of German Journeymen*
1969 Triennal Stuttgart *Internationales Kunsthandwerk*
1970 Fockemuseum Bremen, *Werkstoff und Form*
1971 Hessen State Award for German Decorative Art, Museum für Kunst und Gewerbe
1973 Ceramic International, Calgary, Canada – Medal
1976 Bavarian State Award, Munich – Gold Medal (1969-76 jointly awarded with Isgard Moje-Wohlgemuth)
1984 *Suntory Museums Prize of Glass '84* in Japan, Tokyo/Kobe, Japan
1985 *Dr Maedebach Memorial-Prize at* second *Coburger Glas-preis für Moderne Glasgestaltung in Europa*
1989 Selected participant for third *International Glass Symposium*, Nový Bor, Czech Republic, supported by grant from the Visual Arts/Craft Board of the Australia Council
1990 *International Glass Exhibition*, Kanazavwa, Japan (silver prize)
1995 Australian Creative Fellowship Award
1996 Honourary Life Membership of the Arbeitsgemeinschaft des Kunsthandwerks, Hamburg, Germany
1997 UrbanGlass Award for 'Innovation in a Glass Working Technique', New York, USA
 Artist-in-Residence, Niijima, Japan
1998- Visiting Fellow, Australian National University, Canberra, Australia
1998 *Canberra Times* 'Artist of the Year ', Canberra, Australia
1999 Bavarian State Award, Munich, Germany
 The Rackow Commission, Corning Museum of Glass, USA
2000 *Lifetime Achievement Award*, Glass Art Society, New York, USA
2001 *Canberra Times 75*, selected as one who has changed the life of the city
 Peoplescape 2001, Parliament House Canberra (presentation of 5000 figures that have shaped Australia)
 Australia Council Emeritus Award
2004 *Lifetime Achievement Award*, UrbanGlass, New York
2005 Australia Council Fellowship
2006 Honorary Officer (AO) in the General Division of the Order of Australia

Selected Bibliography

Cochrane, Grace. *The Craft Movement in Australia: A history*, New South Wales University Press, Sydney, 1992

Edwards, Geoffrey. *Art of Glass: Glass in the Collection of the National Gallery of Victoria*, National Gallery of Victoria, Melbourne, 1998

Edwards, Geoffrey. *Klaus Moje Glass/Glas: A Retrospective Exhibition/Eine Retrospective*, National Gallery of Victoria, Melbourne, 1995

Edwards, Geoffrey. 'A sea-change into something rich and strange', *Craft Arts International*, Issue 34, 1995, pp 47-51

Franz, Susanne K. *Contemporary Glass*, Harry N Abrams Inc Publishing, New York, 1989

Gray, Anna [Ed]. *Australian Art: In the National Gallery of Australia*, National Gallery of Australia, Canberra, 2002

Hawkins Opie, Jennifer. *Contemporary International Glass: 60 Artists in the V&A*, V&A Publications, London, 2004

Hollister, Paul. 'Klaus Moje', *American Craft*, vol. 44, #6, December 1984–January 1985, pp18-22

Iannou, Noris. *Australian Studio Glass: The movement, its makers and their art*, Craftsman House, Sydney, 1995

Joppien, Rüdiger. Essay, 'Klaus Moje: Glass/glas', National Gallery of Victoria, Melbourne, 1995

Klein, Dan, and Lloyd, Ward. *The History of Glass*, Orbis Publishing Ltd, London, 1984